NEWSPAPER PHOTOGRAPHY

NEWSPAPER PHOTOGRAPHY
A Professional View of Photojournalism Today

ALUN JOHN
Picture Editor of *THE INDEPENDENT*

The Crowood Press

First published in 1988 by
The Crowood Press
Ramsbury, Marlborough,
Wiltshire SN8 2HE

British Library Cataloguing in Publication Data
John, Alun
Newspaper photography – a professional
view of photojournalism today.
1. Photojournalism, manuals
I. Title
778.9′907

ISBN 1 85223 079 7

Acknowledgements

Many of the images in this book have been made by *The Independent*'s
own team of photographers who daily produce such superb results in the
paper – David Ashdown, Keith Dobney, Brian Harris, Suresh Karadia,
Herbie Knott, Jeremy Nicholl, David Rose, Michael Steele, John Voos.
Thank you boys. . . . Thank you also to Michael Spillard, my deputy,
Frances Cutler, my assistant, and Sarah Heneghan, my secretary.
My grateful thanks to my wife Sara for her constant help and support and
hours at the typewriter.

This book is dedicated to my late father, Guy John, who
bought me an Ilford Sportsman camera and a Gnome
enlarger. He built me a darkroom under the stairs and set me
on the road to Fleet Street.

Typeset by Avonset, Midsomer Norton, Bath
Printed in Great Britain at the University Printing House, Oxford

CONTENTS

Foreword

I am glad to commend this book on news photography. My colleague, Alun John, has written it at a timely moment. For newspaper photographs can now deliver the same power – to shock, to explain, to illuminate, to comment – as moving pictures on television and in the cinema. The frozen moment in the black and white still picture published in a newspaper carries as much meaning as a thousand well-chosen words or the striking colours of the screen.

The print media are fully competitive in conveying images, helped as they have been by improvements in standards of reproduction and the emergence of a class of exceptionally gifted photographers.

Andreas Whittam Smith
Editor of *The Independent*

Introduction

This is a strange book – I'm not really certain what it is, rather what it's not. It isn't a textbook. You will find lots of practical help with photography in it, but you certainly won't be able to pass any exams and put letters after your name after reading it. It isn't a biography of anyone, but you will find much in it that will illustrate well the life of a news photographer. It *is* a reflection of the many facets that make up the varied life of a newspaper photographer. Every one I know and all those you can read about in this book, stress one thing – variety. This is the key word that describes the life. You literally will not know from one day to the next what you are doing.

I decided to write the book after the great success of *The Independent*'s pictures – I received so many letters and phone calls remarking on their impact that I figured I must be doing something right. I have spoken to groups of photographers, and to people interested in pictures, from local camera clubs up to the Royal Photographic Society, and the warmth of my reception at all these gatherings has spurred me on to writing.

Newspaper Photography will take you along the road that leads to Fleet Street (or wherever it is these days that national and international papers are published). One day you may like to embark on such a career; you may like to read of it; or you may just want to see the results of it on your breakfast table. Whatever your approach, I hope this book will help you to understand the immense skills that are used daily to bring the world to you in pictures.

I have been lucky in photography – it has been good to me. It has taken me from my beginnings in the darkroom of the *South Wales Echo* in Cardiff, to become the first Fleet Street Picture Editor to be honoured by Granada Television's *What the Papers Say* at a glittering lunch at The Savoy.

In between, it has put me on the streets of Belfast and in the Music Room of Buckingham Palace. It has walked me down Fifth Avenue in New York, and has let me see the dawn break

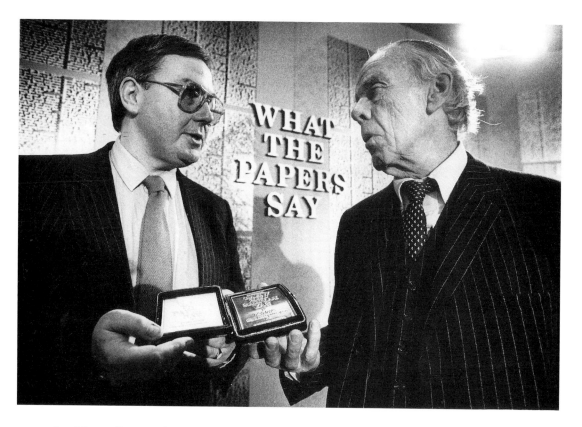

over the River Ganges in India. It has taken me from the depth of human tragedy at Aberfan, to breaking the sound barrier over the Atlantic in Concorde with a glass of champagne in my hand.

So it's been good to me. I hope that after reading this book it can be equally good to some of you.

Alun John receives The Gerald Barry Award from Granada Television's *What The Papers Say*, presented by Lord Deedes at The Savoy.
KEITH DOBNEY

How to Break In

Everyone's idea of the Press! A posse of photographers at work outside Bow Street Magistrates' Court covering the Guinness Scandal.
KEITH DOBNEY

Imagine how wonderful it must be to be able to show your pictures to eight million people. You get a ripple of excitement when you hand around your holiday snaps and the family 'ooh!' and 'ah!' over them – how would you like to put your work through letter-boxes in every town and village in the country? How would you like to know that *your* idea, the moment that *you* captured, or the story that *you* illustrated will be in thousands upon thousands of homes by the next morning? The key to this tremendous photographic power is newspapers.

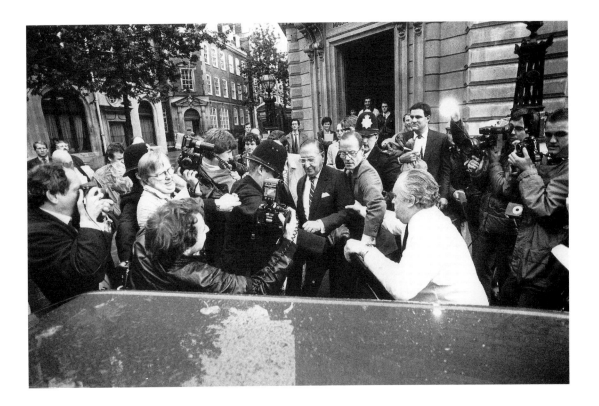

Once seen as a low point in photography, newspapers are currently undergoing a revolution, not only in the way they are produced, but also in the way that photographers are able to contribute to their content. For years, the name 'press photographer' has been used as a term of abuse, conjuring up images of grubby men in even grubbier raincoats chasing miscreants along the street, or persuading actresses to 'show us a bit more leg, luv'. Those days are now gone, and with the wealth of new technology available on a national scale, news photographers are fast emerging as the leaders in the newspaper revolution.

The revolution is here, and I am pleased to say that I am part of it. I came to Fleet Street at a time when unions had a stranglehold on the production and printing, and people who were bankrupt in picture ideas and training had control over photography. Now the production side of newspapers is on a much smoother run. I can't remember the last time a paper failed to appear, and I can't remember the last time the 'inkies' held another disruptive meeting, and stopped the journalists' work reaching the readers. Also the Picture Editor is being listened to by his Editor.

No longer are pictures seen as devices for filling up space when words fall short; they are now appreciated for what they are – a vital ingredient in the journalistic package that is a newspaper. Indeed, at *The Independent* they are acknowledged as attracting readers to the paper – they catch the eye of the buyer well before he passes on to the articles and features of the paper.

Pictures are a powerful medium. They can inform, amuse, shock or amaze, and, properly displayed, they can be objects of beauty and creativity. They can portray the whole range of human emotion, from despair to elation, far better than mere words ever can, and their images remain in people's minds for years.

How, then, to enter this world? Some photographers wouldn't work for a newspaper for the proverbial gold watch, and it has to be said that some, despite their sniffy attitude towards the news photographer, wouldn't last until lunch-time on the street. Still others wouldn't even be able to find the newspaper office without a detailed map and compass!

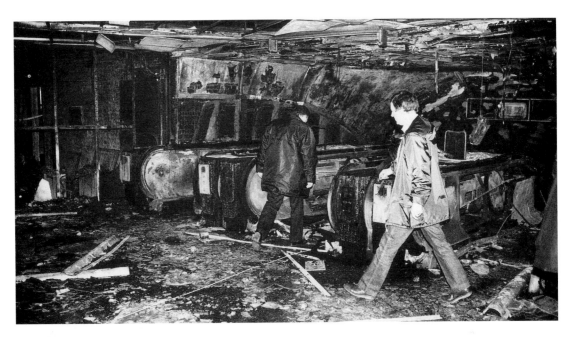

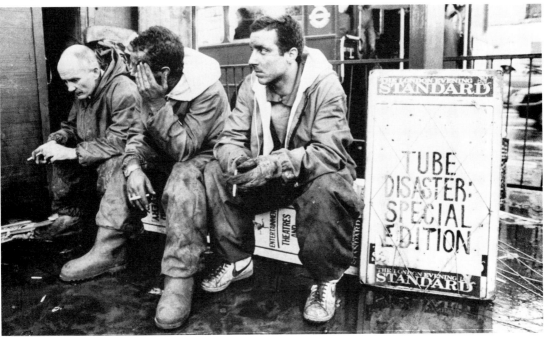

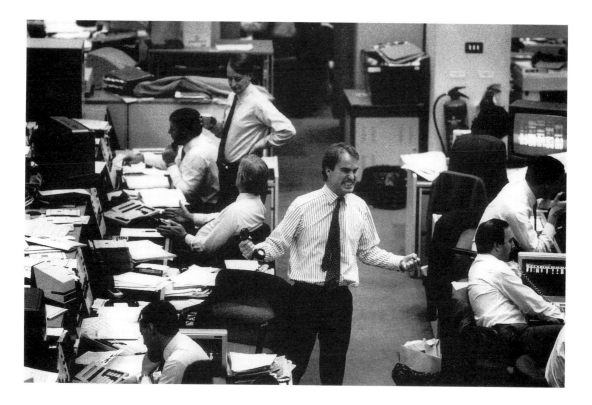

So what skills does a news photographer need? How does he break in? My own view on this is that, if you have to ask too many questions, you won't get too far along the line in news photography. There is no formal entry structure. You can get a certificate of proficiency in news photography, but that doesn't make you into a news photographer by right. News photography is a process which is best done instinctively, and in my experience the most interesting pictures are got by instinct. You need to know exactly what sort of picture will best illustrate the story, and the best photographers act spontaneously to get them.

There is a direct parallel between newspapers and the entertainment world. In both, there are stars and chorus players, and not everyone can be (or even wants to be) a star. For every name in lights or in a byline there are hundreds who are content to stay in the chorus or who want to work for

Above Elation. Part of a series of pictures taken on the trading floor in the City during the chaos that followed 'Black Monday' in October 1987.
BRIAN HARRIS

Opposite above Despair. The aftermath of the King's Cross fire disaster.
KEITH DOBNEY

Opposite below Despair. The morning after the King's Cross fire disaster. This sums up much of the emotion and hard labour of the rescue services.
KEITH DOBNEY

Right All part of showbiz! Mick Jagger at an open air concert at Knebworth in the late 1960s. This picture was taken after waiting for hours in the middle of the night with the air heavy with the smell of exotic cheroots. It was accepted for the World Press Photo Competition in Holland and was used in a world-wide travelling exhibition. It also featured in Harold Evans' book *Eyewitness*, featuring the best of twenty-five years of the competition.
ALUN JOHN

Opposite An image that lingers in the memory. As the anniversary of the tragic kidnapping of Church envoy Terry Waite approached I was struggling to think of a picture which would sum up the feelings of those people anxiously awaiting his release. I contacted the helpful Church of England Press Office at Lambeth Palace who said that they had no special plans to mark the event, but that Terry was always in their thoughts and prayers, and that they would continue to light a candle each day for him in their own chapel in the basement of the Palace. I could see the potential of this and sent Brian Harris along to see them. Using his not inconsiderable charm he persuaded one of the Sisters, normally a shy, retiring figure, to pose for this beautifully arranged and composed picture which appeared on the front page of *The Independent* on the anniversary day.
BRIAN HARRIS

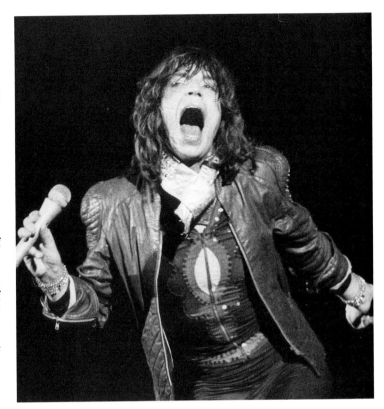

newspapers which are smaller or cosier than nationals. (An aside here – what do we call the collection of national papers now that none of them publish in Fleet Street itself? Today they are dispersed around London, in converted shops in Kensington and gleaming factories in Docklands. I think we should stick to 'Fleet Street' – we're all still there in spirit, if not in spirits, as we used to be in El Vino's.)

To return to the show business theme, we're all only as good as our last efforts, and we stand or fall each morning on the results of competitors. It's rather like making a record every day, and seeing what number you manage to reach in the charts. Everyone, Picture Editor and photographer alike, is in a highly competitive situation. The photographer is sometimes literally shoulder to shoulder with his rivals, and the Picture Editor is constantly searching for a different angle

on a story, to mark his efforts as better than his colleague's on an opposing paper.

For we are in opposition. We all of us exist in the real world where if the paper doesn't sell, it doesn't make money. If this happens it will fail, or be swallowed up into a larger group and probably lose its credibility. To sell, the paper must be better than its competitors in some way, either by being more balanced, or by offering something more than the others. In this respect, pictures are making an increasingly important contribution.

Shortly after the launch of *The Independent* I received hundreds of readers' letters. Among them was one which I've framed and which sits on my desk. 'Your pictures', it said, 'are the only images that stick in my mind long after I've lit the fire with the newspaper.' This caused us all to smile but it was, in fact, saying a great truth about news. It is a passing

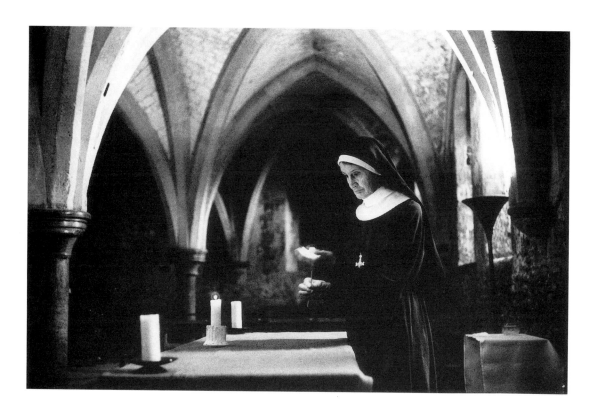

medium, something with advantages and disadvantages. If you've had a bad day then it's soon over, and you're on to the next set of challenges. If you've had a good day then, yes, it's sad to think that by the end of the week your efforts could be wrapped around cod and chips. But the value of a news photograph is stepping outside its daily splash more and more, and collections are springing up, housing what is, after all (if you'll excuse me for being pompous), a rough draft of history. Television will never kill newspapers because, although you can watch the news happening in your sitting room with a gin and tonic in your hand, it's soon gone and one of the great joys of photography is that you are left with something to have and to hold, as they say.

Enough of the theory – how *do* you get into the world of news?

To start with, don't think too big! News is happening all around, and not all the news events will be reported in the

All my own work! An amusing and effective way to portray an artist and his forthcoming exhibition.
BRIAN HARRIS

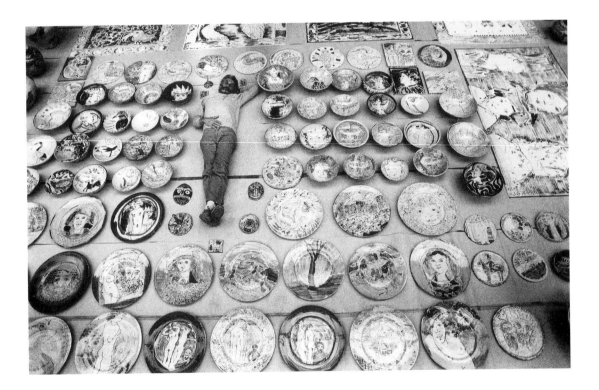

national press. Take a look at your local paper and see the sort of thing that they report – you note I said 'report', and I did so for a purpose.

It has to be said that the level of photography in most of our weekly papers is not high. This is for several reasons. As I said earlier, in some cases the Editor knows nothing of pictures or picture people, and some of them don't want to know either. This seems to me to be a great shame – I'm sure that readers would far rather look at interesting pictures of local events, rather than the usual ones of the mayor shaking hands with some other worthy, both staring at the camera. (These are known as 'grip and grin' pictures and I call them 'grip and grim'!) The endless production of this sort of picture is largely due to laziness on the part of the photographer, coupled with his familiarity with a subject that he has covered for the last ten years; it is also due to the Editor having no desire to develop the paper and no interest in making any progress. He will argue that faces in a newspaper picture sell copies, and this is a difficult argument to defeat, unless you have more than a passing interest in quality. Perhaps it's true that, if fifty people from a local society have been photographed together, it's a fair bet that some of them will want a copy, either of the paper or of the picture. It's a bit of a sad reflection on the journalism in the rest of the paper, though, if this is seen as the right way to sell the publication – the journalistic endeavour of the rest of the staff ought to be reaping rewards too.

Back again to the pictures. One simple event that might be worth covering for your local paper would be a family wedding anniversary party. Usually it would probably have to be a golden one to grace the pages, but, if you do offer a good picture from a silver, it may stand a chance.

Approach the task with a little thought, and do a certain amount of preparation. Generally, don't try to take the pictures when the party is in full swing – if you want to take an extra shot or do a little arranging of things, then there will be too many relatives milling around with drinks in their hands to help. Try to take the picture a few days before the party. The couple will be more relaxed and the whole house should be quiet. I like to see a close-up of the couple, well lit either

by bounce flash or by natural light. Get them close together (remember, space is at a premium in a newspaper); possibly they could put their arms around each other, and incline their heads together. They could share a toast or be looking at one of their cards. If either has a particular hobby or interest, then one could be seen enjoying it. Perhaps they are keen gardeners, or if the husband is a keen DIY man they could be doing something together. I don't think I've ever seen a golden wedding couple mixing cement together, but it would be original and it could even make the front page!

Another little tip to get more inches in the paper for yourself would be to ask if they have either an engagement or wedding-day picture of themselves, and to pose them up in exactly the same way as the original. Then copy the original (if it's precious) and submit both pictures. That way you should get twice the space!

Develop the film and make a print – it need not be bigger than 8 × 6in for a local paper. You should offer a choice of either upright or landscape formats to make things easier for the page design, and you must also submit a full caption, preferably typed and stuck to the back of the print. It should have as much information as you can get and maybe even include a 'quote':

'Mr and Mrs William and Mary Brown, who this week celebrate their golden wedding at their home in Station Road, Anytown. Mr Brown worked at the local branch of Boyds Bank for twenty-three years before his retirement eight years ago. The couple have two children and three grandchildren, and plan to celebrate the event by taking a short holiday at Bognor. Said Mr Brown: ''Mary and I have had a wonderful life together, and we are looking forward to seeing all our family and friends at our party''.'

Send the picture by post in plenty of time, or drop it in yourself. Notice here that the picture was taken before the event, and so the caption is written in the future tense. It is always better to anticipate an event like this – newspapers like to be ahead of the news, and as an added bonus, if there wasn't enough space one week, it wouldn't look out of place

if they held the picture and used it the week after.

Realistically you will not make a fortune from your first publication – in fact, you probably won't get paid at all. Most local newspapers simply cannot afford it. Settle for a byline or picture credit with your name on it. In the initial stages it will help your reputation and enhance your credibility with other assignments you may attempt.

It is most important initially that you find the assignments yourself. At this stage no one will offer you any work because they won't have heard of you, and the bylines will be valuable. After a couple of editions, get to know the Chief Photographer on a paper, and befriend him. You never know, he might be stuck for a photographer one day and you may be able to step into the breach.

Being in the right place at the right time is part of what news photography is about. The first front page picture I shot was

Choose an unconventional approach if you can. Choir boys leaving school for church at King's College, Cambridge.
JEREMY NICHOLL

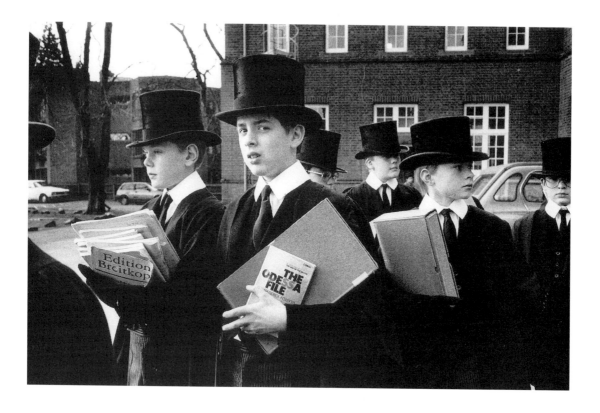

Opposite My first front page
picture, published in the *South
Wales Echo* in January 1967, an
accident at the Guest Keen Iron
and Steel Works in Cardiff Docks.
One of the drivers was killed.
ALUN JOHN

got through luck. I was an assistant in the darkroom of the *South Wales Echo* in Cardiff (and making tea for the Picture Desk), when a reporter came round saying he had to go immediately to a fatal accident at the steel works in Cardiff Docks. There were no photographers available, they were all out on other stories, and I was sent with the reporter in an office car to the scene. I used my Yashica to take a roll of film of the two lorries that had crashed, and then we sped back to the office. I processed and printed my film, handed a couple of prints to the Picture Editor, and in the afternoon saw my efforts on the front page. I felt ten feet tall and rang all my friends, telling them to be sure to buy the *Echo* that night, because I'd taken the front page picture. The other photographers bought me a beer after work and I felt that I was on the way. I phoned my aunts and uncles and spread the word as far as I could – I was thrilled. I still have that cutting in the loft, and I must admit to a little lump in my throat when I look at it now.

That picture of the lorries wasn't my first published one, though. When my late father retired from his job, I took a picture of him being presented with silver tray by his colleagues, and it was published in a trade union journal. I then trod the route followed by most people who break into photography. Small assignments – presentations, golden weddings and afternoon fêtes – were offered and eagerly accepted.

In your early stages, never turn anything down. There is no such thing as bad experience, and if you make mistakes you simply have to try not to repeat them. Years after my first front page picture, I remember getting a really important exclusive of a drug dealer that everyone had been trying to get at a long-running trial in Bristol. I was then working for the Press Association, Britain's national news agency. Buoyed up by my elation at nailing him, I sped round to the darkroom of the *Bristol Evening Post* (which I had not used before) and processed the film. I developed it for the required time and placed the spiral in the fix. Two minutes later I put the light on and pulled out the spiral, only to watch in disbelief as the images started to fade – I had put the spiral in another tank of developer and not in the fix. I hastily threw it into the fix and

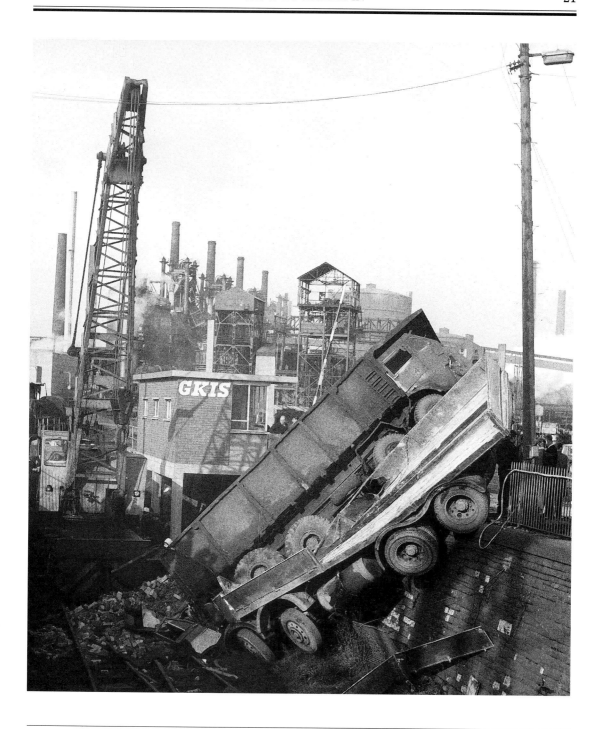

put out the light; it turned out to be all right – the frame was in the centre of the spiral. The motto of the story is: don't ever assume you know which chemicals are in which tanks – I never did again!

But back to basics. Take a good look at your local paper and see if anything in it catches your eye, or if you feel that you might produce a picture from your own resources. Try and produce pictures along the lines that they use. Remember, it is their paper and they know what they want. Continue to offer pictures, and, if they have been appearing regularly, ask if they could offer you some of their work, and if they would consider replacing the materials you have used. This may go down better than asking for hard money. If you are a keen amateur you really cannot think of depriving full-time photographers of their income, and unless you are prepared to become a full-time photographer yourself, I don't feel that you should do so. You may consider offering help as a second photographer when they have a particularly big assignment on. An extra pair of hands and (more important) eyes could be useful. But if you never want to be any more than an enthusiastic amateur, you shouldn't get in the way of people who are trying to make a living for themselves.

One other important point to remember at this stage is to be meticulous with captions. Nothing upsets people more than spelling their names incorrectly, or getting them wrong. If you're not sure, ask. Check the spelling of names – is it Stephen or Steven? People would far rather be asked – these days I know it's not fashionable to ask a lady if she's Miss or Mrs, but you should really. I once asked a foreign lady, after checking the tricky spelling of her name, if it was Miss or Mrs and her crisp reply was 'Countess actually!'.

Also, don't be intimidated by people with chains around their necks; they are just like you and I, and they've simply been elected something for a year. Last year they were Mr, and next year they will probably be Mr again. I'm not suggesting for a moment that you should be rude, but do remember that you are the photographer and they are the subject, and that they will sometimes need discreet but firm direction.

On the practical side, find out which day is press day for the

paper. Find out the name of the editor – it's much nicer to write a letter to someone if you know who he is. However, don't be too familiar. If his name is Bill Brown, and you've never met him, don't start your letter 'Dear Bill' – again this is simply courtesy. Also, however dull you may think the pictures he uses in his paper are, do try to be a little diplomatic in your approach. No editor will be impressed by a newcomer telling him that he's not doing his job properly. To some extent, the role of a news photographer on a weekly paper is to educate by example, so submitting a picture which takes a fresh look at an old subject may well give the Editor a chance to try something just a little different. Newspaper readers are conservative people by nature, and they resent sudden changes to an established regime or presentation. You will not change your local paper overnight, but you may improve it slowly. Unless you start from scratch like we did at *The Independent*, you would be better off changing the system slowly, rather than trying to rush in, upsetting people and alienating yourself from them.

A last note in this chapter. The question I'm most frequently asked by amateurs is, 'What do I do with an amazing exclusive shot?' (they usually call it a 'scoop', but I can't honestly recall any journalist ever telling me he had a 'scoop'; they're called 'exclusives' in the business). The answer is simple. Once you've got your picture of a bank robbery, don't take the film out of the camera. In your excitement you may forget to rewind it and fog it. Telephone the Picture Desk of a newspaper – all papers take transfer charge calls. Ask for the duty Picture Editor (most picture editors don't work every single day!); don't assume that any woman who answers the phone is not capable of sensible thought – on a picture desk, everyone is. Explain what you've seen and what you think you've got. Don't get too involved in explaining the model numbers of the camera and lens, just say it's a good quality camera. If the film is black and white, and most newspapers still prefer it, just indicate roughly if the film needs to be 'pushed', or uprated.

The Picture Editor will then ask a few general questions about the story, and will decide if he wants it or not. If you are near London he will ask you either to come in, if it's

Animals are always a popular subject. Here, the Lord Mayor's horses await the start of the Lord Mayor's Show at their stables in Chiswell Street.
KEITH DOBNEY

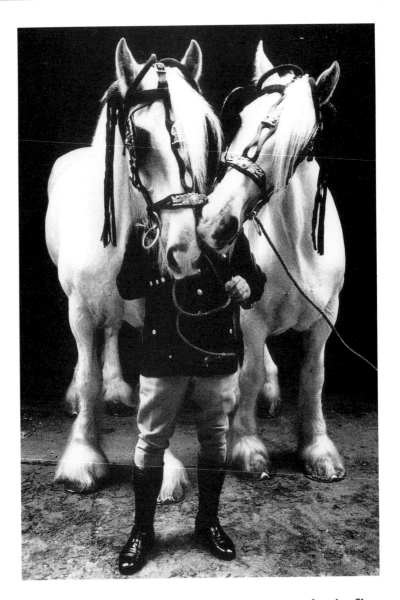

convenient, or he may send a messenger to you for the film. If you are a long way from London he may send round a local freelance to collect and process it. Don't worry, he won't rip you off – he daren't; his reputation would be so tarnished he probably wouldn't work for the paper again. Write a caption

on the incident and don't forget to include your home address – this is a minor point that's easily forgotten.

You may be asked to speak to the News Desk, and they will probably put you in touch with a reporter who will debrief you on what you saw.

At this stage, don't quibble too much about money. A national paper will not rip you off – again, it's not in their interests to do so. You will probably be overpaid if the picture is used, in the hope that, if you see the same type of thing again, you will offer it to the same newspaper.

Ask to have your name on the picture and, if the newspaper suggests it, let them syndicate it or distribute it for you, taking a percentage. They will make far more money than you will ever make on your own.

You should never lose sight of the fact that there is a potential source of income from your pictures past their first publication.

Most newspapers gain a good source of revenue from the syndicated sales of their pictures. They will either sell them themselves or employ an agent to act on their behalf. There are many other newspapers in the world that may be interested in using the pictures after they have already appeared once in the UK.

Just as with articles, pictures (provided they are of a relatively timeless appeal) can be used time and time again. They may be sold for just one publication, or for subsequent use in the future. This is sometimes used as a way of off-setting the cost of an expensive assignment. After laying out thousands of pounds, a newspaper will attempt to recoup some of the money by selling to other newspapers that are not in direct competition. With freelance photographers they will come to a mutually agreeable percentage, to be split between them after the distribution expenses have been covered.

There are also many agencies who will undertake to sell photographers' pictures on their behalf, again on a straight percentage deal. They will make all the arrangements for printing, captioning and distribution, in return for their cut, leaving the photographer free to concentrate on taking the pictures. Many photographers make a very good living from the foreign sales of their material, Royal subjects and animals

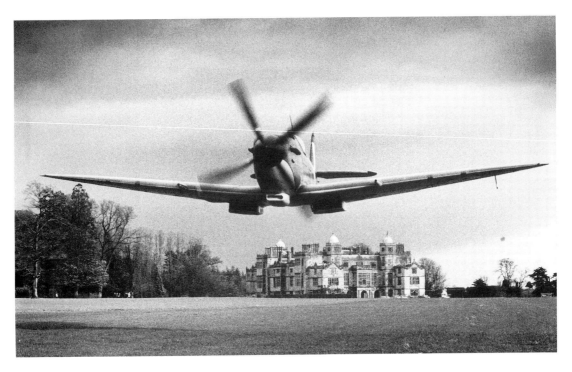

A Mark IX Spitfire flown by former Red Arrow pilot Ray Hanna makes a low pass over the grass airstrip at Charlton Park, Wiltshire, during filming for an LWT wartime drama. This is the top-selling photograph to *Independent* readers. At *The Independent*'s Christmas party in 1987 the desk staff presented Herbie with a Spitfire construction kit and hoped it would keep him occupied for as long as we had been in answering the telephones!
HERBIE KNOTT

being particularly good sellers. Also, most newspapers sell copies of their photographs to their readers for their own enjoyment; usually a small charge is made to cover the production costs and postage.

A reputable agency will not allow your photographs to be used in any publication where you may not wish them to appear, and they will be meticulous with their statement of sales, which is usually issued quarterly, so that you are in no danger of being exploited. Some agencies specialise in different subjects, and picture researchers the world over will be familiar with their various specialities.

It is far better to place your work with an agency, giving it a chance of being sold to another source, than to keep it in a shoebox at home gathering dust and not much else.

The tabloids pay significantly more than the qualities for an exclusive, but if you see Lord Lucan riding Shergar, then *do* give me a ring first.

Getting Yourself Known

In the last chapter you've been set on course for the odd picture in the local paper – fame enough, you may suppose, but how to progress further?

Not everyone wants to progress further. As an amateur there are really no pressures on you – those that there are will be, to a certain extent, of your own making. Any part-time activity that you indulge in will eventually reach a point where, if you wish, it could be taken further. While you've got a full-time job it can't take priority since it doesn't pay the bills – inevitably, there will be times when, due to work, you may not be able to attend a function, or go to a specific event to take pictures. This, I'm afraid, is a fact of life, and unless you have an understanding employer such will always be the case. However, as an amateur all that you lose if you miss out on a picture opportunity is your own satisfaction.

Not so for the professional. He makes his living from pictures, and a job missed is money lost. The pressures on him are great. If the amateur photographer has a hangover and is thinking of going to photograph some ducks this morning, well, it's not the end of the world if he wisely decides to have a quiet morning; or, if the light isn't quite up to it, he can plan a reshoot next week; or, if the car won't start, he can spend an hour or so repairing it. When you are taking pictures for a living you can afford none of these luxuries. All pictures are taken to a deadline (however lax that may be), and this means that professional photographers must enforce some sort of discipline on themselves. It's no good saying to a client that you didn't feel like taking his picture today, and that you may feel more like it in the morning; you have to dust yourself and your lens off, and get on with it.

This is even more important with newspapers, where a deadline is usually a couple of hours away. How many of you could be rung up in the middle of the night, be packed off to a

strange town or city, track down the person you needed, persuade them to be photographed, get your material back to the office, get it processed and printed, and then be told that there's no space for the picture after all, and after that go home and raise the enthusiasm to try again the next day? It's a tall order, but a basic part of the news photographer's life.

The actual number of pictures that see the light of day in national papers varies enormously. In the tabloids it may be as low as one in fifty assignments. Indeed, I know of one photographer on a tabloid newspaper who went a year without getting a sniff of a publication. On other tabloids, one a month seems to be the average, and one a week is the exception. This is not as wasteful as it seems. Every day there are many pages to be filled in tabloid newspapers. However, on most days there's a fair volume of work and early in the day it's not always possible to assess accurately the end-product of an assignment – some will fail to come up with the goods, some will fizzle out as the story subsides, and others will produce much better pictures than you at first anticipated. The only way you can see if an assignment works is by sending a photographer out to look at it.

On quality newspapers the scoring rate is higher, the number of staff is lower and editing is tighter. It may be of interest that the figures I keep at *The Independent* show that our photographers regularly have a strike rate of around eighty-five per cent, a very high figure and possibly the highest in Fleet Street (wherever that is!). This works well for us – the photographers know that their work will probably appear, and so they work harder to produce better pictures. Also, the pictures are displayed better and this encourages the photographers to try harder still. It's a good situation, helping the standards to rise all the time, and something we work very hard at on the paper.

Earlier I said that news photography was like show business and indeed the parallels are very strong. At any one time there are many more freelances struggling to make ends meet than there are stars driving around in Rolls-Royces (there are three photographers I know personally who do the latter). So, having taken your local paper by storm, how do you take the first steps on the road to Fleet Street?

One thing that is for sure is that you will have to walk towards it – there's no way it's going to walk towards you! Remember the acting metaphor and keep auditioning.

You need to feel comfortable with photography. This is an important point – you must be happy doing it, you must have a feel for it, and you must be able to strike up an affinity with people. They are your raw material. It's no good being able to light a tricky studio shot perfectly if you're afraid to approach total strangers, and persuade them into situations where they might not be happy to be seen. For a picture you have to be able to push yourself forward; you have to be the type of person who can walk into a room and gently but firmly take charge of a group of people, and get them quickly round to your way of thinking.

You may find that you enjoy taking certain types of picture more than others. You may also find that you surprise yourself, discovering that your strength lies in something you may not have even bothered to think about before; if you're really comfortable and confident in this field, that could be a way forward for you.

Many photographers have made a good name and a good living out of a speciality – such as sport, or portraiture, or animals – but they will definitely have established themselves as the best men for the job. Don't get too specialised though; there is a limit to diversification, and you probably won't want to become known as the best man in the country for photographing marrows! Equally, it has to be said that if you do fall deeply in love with a particular subject, you should immerse yourself in it and really become an expert. This, to my mind, must be heaven on earth – to be paid for doing something that you perhaps might even have paid to do.

Build up a set of pictures in your speciality, and constantly update them. Be ruthless and discard those that fall below your (hopefully) improving standards. Cultivate the experts in your chosen field – don't forget to give them complimentary prints of anything that you think may be of interest to them. A print costs a few pence and that little thoughtful act on your part may be repaid later – I think it's called 'casting your bread on the waters'. If you do promise someone a print then don't forget to send it; after all, it's only basic courtesy.

A good example of how newspaper photographers have to be prepared to set off at a moment's notice on assignment. David Rose was on standby for two weeks waiting for the birth of this baby in Cornwall. He knew that the birth was going to be in a paddling pool of tepid water in the sitting room of a remote cottage near the coast. He was alerted at midnight that labour had started and set off in his car along the motorway to Cornwall in a rainstorm. Arriving four hours later he started work, using the limited amount of light available, and trying not to intrude on a very personal moment. This is a good example of the lack of warning photographers sometimes experience before having to travel long distances to locations that are not favourable for easy photography; David Rose succeeded this time in producing a very moving series of photographs.
DAVID ROSE

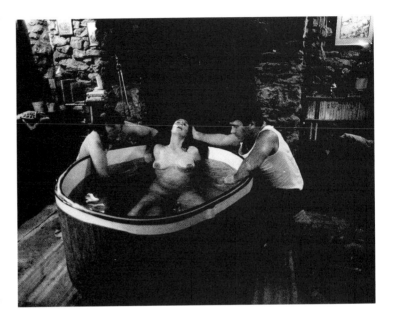

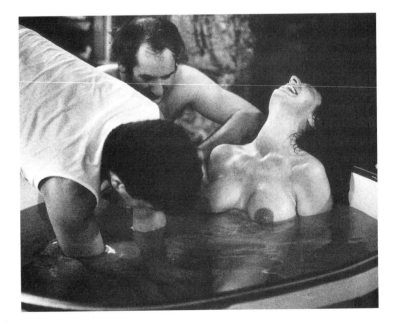

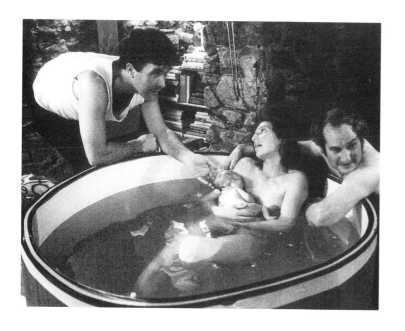

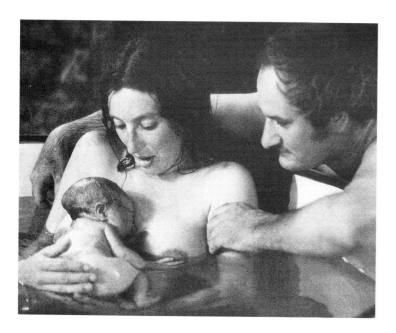

You may feel that the time has come to approach a picture editor. To some people this is rather daunting. Actually going into the office of a national newspaper with your wares is indeed a big step, so you must make sure you're ready for it. Don't undersell yourself, but, equally, don't try to run before you can walk – it's a big step from amateur dramatics to the Royal Shakespeare Company, and very few people manage it in one attempt. The same applies to photography. It will take many tries to break in, and it's unlikely that you'll be snapped up the first time. To put this in perspective, I see three new photographers a week at *The Independent* – you can work out how many that is a year for yourself.

Day-to-day news photography is undeniably a young person's game, however, there will always be the exception that proves the rule.

When you decide to approach the Picture Editor, don't try to turn up without an appointment. You will probably find that you have come at a bad time – we are all businessmen as well as editors, and much of our time is taken up with budget and policy meetings, as well as with marking contacts. Find out the name of the person you are trying to see (if you can't manage that piece of initiative then what hope for your career!). Don't worry if you can't speak directly to him; he'll never have heard of you, so why should he speak to you? Try to ring at a quiet time. In evening papers the morning is busy and the afternoon quiet, on a morning paper the situation is reversed. The morning is quieter and people will generally have a little more time to talk. A letter is not a bad idea, either. Be brief – don't send a six-pager, but try to get it all on one sheet. The most valuable commodity for any journalist is time, so you don't want to try and hold the Editor's attention for too long. Also, don't just wait to be asked. I've had letters from people saying, 'here I am, just ring me when you want; I'm available to travel anywhere in the world for you'. These go straight in the bin. It's arrogant and rude, and if I'm going to send people away, then one of my staff photographers will go.

Don't be afraid to be witty, but don't be over-familiar either. Don't send any pictures at this stage – they may get lost and gum up the works on the Desk. We get over 300 pictures a day across ours, so you can't afford to take any risks.

You may well be written to and asked to phone a secretary to arrange an appointment. Please be nice to secretaries – they are valuable friends to you. Sarah, my secretary, is terrific, acting as a sieve for me, leaving out all the things she knows I don't want, and streamlining the administration work. Don't be pushy or aggressive with them, since nothing creates a worse impression than a secretary saying, 'there's an unpleasant chap on the line who insists on speaking to you'. That sort of thing won't get anyone off on the right foot. If you do speak to the Picture Editor, just confirm that you will be available at the time suggested (if it is convenient); don't ask him how to find the office or where to park your car. Frankly, that's your problem, not his, and again it won't help your efforts to create a good impression.

Turn up on time on the day. I know that seems obvious, but, believe me, dozens of people don't. Try and look reasonably respectable – I don't mean a Savile Row suit with all the trimmings, but at least clean your shoes and brush your hair, and wear some clean clothes (this is the voice of experience speaking here). Photographers have to dress for the occasion. Sometimes this will be jeans and a jumper (perfectly acceptable in the right place), but sometimes, in

Dressed for the occasion? An occupational hazard for (left to right) Keith Waldegrave (*Mail on Sunday*), Peter Kemp (Associated Press), Bill Rowntree (*Daily Mirror*) and Herbie Knott (*Sunday Times*).
ASHLEY ASHWOOD

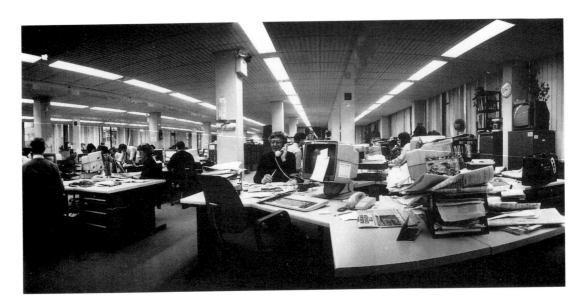

New technology. The News Room
at *The Independent*.

more formal settings, a shirt and tie might be needed, or even
a suit. I wouldn't expect a photographer to work on a building
site in a suit, and I wouldn't expect him to turn up at
Buckingham Palace or Downing Street in jeans and dirty
boots.

Anyway, come in and sit down. You have ten minutes,
that's all – that's the maximum amount of time a picture
editor will probably be able to spare you. A fact of life here. In
new technology offices do be very careful where you put your
things on his desk. Most of us have computer keyboards, and
a portfolio resting on the delete key is not the way to win
friends and influence people!

Have a little CV prepared, nothing elaborate, just a brief
outline of your experience. Type it, don't write it. Tell the
Editor a little about yourself – where you're from, what you
feel you're best at – and then he will probably ask to see your
portfolio.

You wouldn't believe the things I've seen presented as
portfolios, ranging from grubby torn 8×6s in a Sainsbury's
bag, to a custom-built wooden case of 20×16s – both were
equally off-putting. Just print about ten pictures which show
the range of your work. Don't worry if the subjects are not

famous (or the football first division), an editor will be looking at the images, not the occasions. Make all the prints the same size (around 12×10 – no bigger). If it is larger, your book will become unwieldy and it will be difficult to find space for it. Tell the Editor if you have printed them yourself; these days most photographers print their pictures in newspaper offices, if they've got the time. A little caption of one or two lines should be included with each shot. Stick the caption on the same page as the print to avoid turning it over, and remember that this is not an article in a camera magazine, so don't put any technical details. Unless you're at a newspaper that uses colour regularly, don't include any slides (if you *must* include any, make them Cibachrome prints). Don't be put off if the Editor leafs through the book quickly; looking at pictures is his job, and he can sum up the portfolio quickly and accurately. If possible, offer an original idea to the Editor, preferably already shot and printed. It might not actually make it, but you will create the impression of trying.

Do not, under any circumstances at all, ask him what he is looking for. The paper is full of that each day, and you should be able to tell extremely easily what he wants. If you haven't got the actual picture to show him, then maybe you could offer

One of my first foreign assignments. A group of Chelsea pensioners had been flown to Paris by British Airways for a day out. This trip introduced me to a great institution – French restaurants – a study of which I have been avidly pursuing to this day!
ALUN JOHN

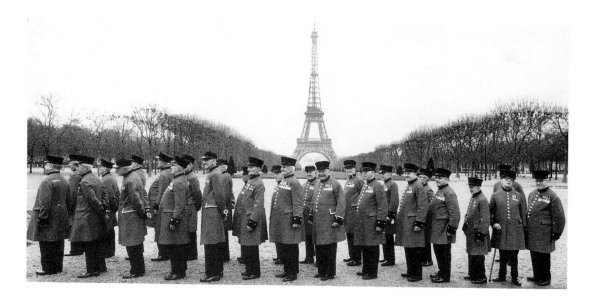

a verbal idea and discuss it. Don't offer to go to the Seychelles – all picture editors work to budgets, and they would far rather hear of a cheap good idea than an expensive flight of fancy.

The time is now slipping away, and you're almost at the end of your ten minutes. Don't worry if you've been interrupted during your discussion – most newspapers are in large, open-plan offices, and one of the main things a picture editor can do is concentrate on several things at once.

At the end, offer a card or neatly-typed address and phone number; again, remember that impressions count, and when you've heard the excuse 'I'm just having some printed' a dozen times before, it wears a bit thin. So, a firm handshake and back out on to the street for you, while the Picture Editor moves on to the next thing in a busy day.

How, then, do you get your assignment? In a word, persistence! Leave a few days and then phone – at a quiet time – and if there's any chance of an assignment you may strike it lucky; or you may not. If after six calls you still haven't been asked, then it's a fair bet you never will be. I never promised it would be easy . . .

You may have made a sufficiently good impression to be offered something fairly swiftly. If you are set on the path to Fleet Street, grasp the opportunity instantly; don't turn it down unless it's absolutely impossible. The offer will only be made once and never repeated. A Picture Editor is there to serve the newspaper, and you will have to fit in with him, and not they with you. I cannot emphasise this too strongly – opportunity knocks but once, as they say. Don't try to tell the Picture Editor how to run his newspaper, because he doesn't need your advice yet.

To get to this stage you must be able to be contacted. A telephone and answering machine are not enough; you need some sort of bleeper, something that will pass a message. Remember, the decision has been made that you are the person for the job, but if you can't be found, someone else will get it. If this happens twice you will be known as difficult to contact, a harsh judgement, but once made, extremely hard to overturn. Remember it is your future.

When you're on the assignment, don't try to be too clever

too soon. Remember that, as a novice you probably won't have been handed the plum job of the day; you may think the job dull but you mustn't let your reach exceed your grasp.

Get back in good time for the deadline (ask when it is), process your film carefully, let the Desk pick something from your contacts, make sure the print is satisfactory, and then, most importantly, write as full a caption as you can, with names and places, and, if there is one, attach a press handout.

After making sure everything is in order ask if there's anything else for you, and if you've only been asked to do one assignment don't hang around and make a nuisance of yourself. It isn't a good idea to bother the Picture Editor with trivia like asking where the toilets are, or where the pens are kept. At this stage a low profile is much the best. You may think that your star has risen, but the reality is more likely to be that you were assigned because there wasn't anyone else. If the pictures you took were good, ask if there may be the possibility of a day's work. Suggest a Sunday – these are the most unpopular with the staff and always need filling. Perhaps you might be offered a late shift, starting around 5 or 6 p.m.

Go into the darkroom and get your film replaced, and then go back into the world. If you've been on a news assignment, don't be too disappointed if it doesn't appear – remember, the odds are against you. If it's more of a feature, or perhaps a City assignment, then it may be in the paper, in which case, may I respectfully suggest a small celebration may be in order.

The Picture Editor will remember you if you have made a good impression, and hopefully the work will come, but remember not to be too pushy with a paper – there are plenty of other people coming along behind you.

On the Job

Equipment

Most photographers fall in love with equipment. It's nice to open a box and unwrap that bubble plastic to expose the gleaming new shine on the body of a camera, carefully putting away that packet of silica gel with the remarkable instruction not to eat it boldly printed on its side. It's even nicer to open a new lens, cast aside the wrapping paper and fit it to the camera, literally opening up new horizons for photography.

Most photographers, I'm afraid, also get seduced by the equipment. Go to a wedding as a pro, and, just before you take a picture of the happy couple, someone will come up and ask politely if they may take one as well. They will open up a case that looks like a shop window, with pristine, gleaming equipment, some still in the original wrappings, and select, sometimes more by luck than judgement, the right lens and body for the job. Camera manufacturers love these people, just like car makers, who only have to introduce a new XL model for users to flock to the showrooms in droves to trade in their old model. Of course, there will be significant improvements in camera design and in lens construction, but amateurs seem to believe everything that manufacturers say, and have to have the latest design, regardless of its suitability for the job.

Have a look inside a news photographer's bag if you get the chance, and you will see that his equipment is chosen according to criteria that are vastly different from those used by amateurs. The main requirement is reliability, and that really must come above and beyond other considerations. These days there is a great trend towards the electronic side of everything, with computers that will work out the focus and exposure, and adjust all the settings automatically. Generally, the news man will avoid these like the proverbial plague, for one main reason – rain! Damp is the great enemy of anything

electrical, and if you have a camera that depends on batteries for all its functions, one day you will throw it away in disgust – a tiny drop of water on a contact will prevent you getting that once-in-a-lifetime picture that could make your reputation, or, possibly even more important, your fortune. Also, unless you are prepared either to carry a stock of batteries or to put new ones in very regularly, then the power source can let you down at the vital moment. It's far better to have a set of equipment that will function mechanically as a standby in an emergency, otherwise you're bound to miss that unrepeatable shot. If you feel that I am totally against all progress, and that perhaps I'm going to recommend plate cameras, don't despair. Photographers should make use of all the technology available to help them take pictures in difficult circumstances, but they should never let technology stand in the way of the final image.

No camera ever took a picture by itself. Just as no computer can produce an original idea, so a camera will only show an image of the object at which it is pointed. If you point your camera at uninteresting subjects then you will take boring pictures, unless you choose an unusual angle from which to press the button.

As we have seen previously, the art of news photography involves being in the right place and pressing the button at the right time. No amount of technology will instil a degree of common sense in the photographer beyond what is already there; experience will improve the photographer, not the purchase of the latest equipment.

On the road you need to strike a balance between what you think will be needed to cover any eventuality, and what you can actually carry. News photography is not a spectator sport – you have to struggle along with everyone else to get the best shots. If you are assigned to follow a politician for a day, you cannot give up at half-time because you feel tired, or because your shoulder is sore from carrying too much gear. You have to go on to the end, in case you miss that elusive shot you've been trying for all day, or if you want to get the shot that everyone else has missed.

The basic kit for news photography should consist of two or three bodies (possibly one with a motor or power winder),

Overleaf above The right place at the right time! Dr David Owen speaking in King's Lynn. At *The Independent*'s first birthday party, Dr Owen told me how much he liked this picture.
BRIAN HARRIS

Overleaf below The right place at the right time! Neil and Glenys Kinnock react to the loud crash as a BBC television crew falls through a window during a visit to his 'local' in his South Wales constituency. This picture won an award from Nikon as the 'Picture of the General Election 1987'.
HERBIE KNOTT

lenses from around 24mm to 200mm, and possibly a two times converter (or 'doubler' as most press boys call it). Throw in a small but powerful flash, a standby light meter, possibly a miniature tripod, and a good supply of film, and that should see you right for most things.

Some photographers favour the use of three bodies at a time, one with a 24mm, one with an 85mm, and one with a 200mm lens attached, and this would cover most eventualities in a moving news story. As you will notice, there is no 'standard' or 55mm lens in that selection – in press work there isn't really a great deal of use for it. Most general views will be taken with the wide angle. Most portraits will be done with the 85mm (from a few feet back), which isolates the subject nicely with its limited depth of field and does not distort the features by getting too close to the subject. The

Below An unusual wide-angle view of a vintage car on display at the RAC club in Pall Mall. KEITH DOBNEY

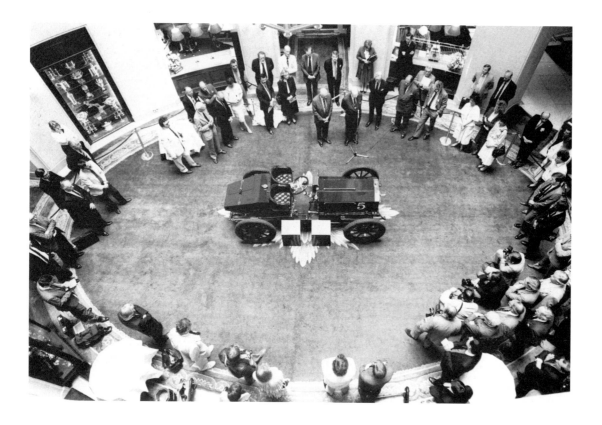

Opposite above At the scene of
a siege in Oxfordshire where a
man held his family at gunpoint.
Taking a break are (left to right)
Peter Case (*Daily Mirror*), Alun
John (Press Association), Peter
Floyd (*Daily Express*), Paul Fievez
(*Daily Mail*), Tom Stoddart (*Daily
Star*), Aubrey Hart (*Standard*). At
the long lens is Jim Hobden (the
Sun).

Opposite below Tiger! Tiger!
Newspaper photographers must be
prepared to go anywhere,
anytime. Herbie Knott joins
Charlie Shea-Simmons (left),
President of the Royal Aero Club,
and stockbroker Jonathan Elwes,
to enjoy the late evening sunshine
over the Berkshire Downs in their
1940s Tiger Moth aircraft.
HERBIE KNOTT

longer lens would be used to get closer to something a little
way off; or, again, it's useful to isolate a subject from its
background which could otherwise be dominant. An
80–200mm zoom lens could be useful, but I still feel that the
quality is not as good as a prime lens.

This is the minimum requirement for news kit – although
some would feel that carrying three bodies is excessive it's an
inescapable fact that you'll be changing lenses just as the shot
you want is happening. Also (and this is something you can try
yourself), running down the road and changing a lens from
your bag at the same time is only just possible!

All the equipment used by a news photographer comes in
for a hard time. It's unavoidable – the sheer volume of work
undertaken by each piece ensures that it won't last long. Most
cameras will have up to six rolls of film a day through them,
and that is rather like clocking up half a million miles a year on
a car. It's small wonder that some of the more reliable
cameras are very sturdy and expensive, and that second-hand
news cameras don't come in mint condition or command high
prices. Also, as much of your time is spent climbing over or
under things, cameras do tend to get dropped quite often.

So, once you've got yourself and your equipment on to the
job, how do you go about things?

Stamina

You do need to be reasonably fit to be a news photographer
and also to possess a reasonable amount of stamina. Very
often you will have to hang around all day on someone's
doorstep, just to catch a quick glimpse of them as they speed
away in their car – you will probably be rewarded with just
three seconds to get your poem in light and shade. You may
also have to stand up for long periods of time as news events
never seem to happen at arm's length from a comfy seat. A
small tip here – even if it is cold, don't drink too much hot
coffee or tea to keep your spirits up. It's sometimes not easy
to find public conveniences out in the wilds, and just as you are
relieving yourself you can bet that you're missing the picture.
News photography is a competitive environment and there's

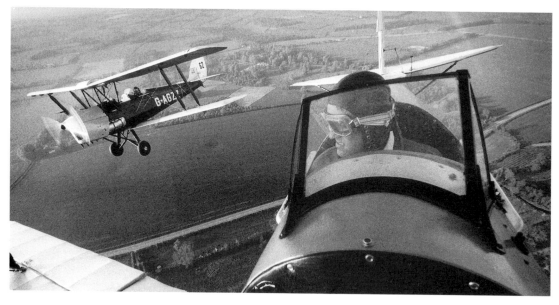

only one thing worse than missing the picture yourself, and that's having someone else get it instead of you.

Transport

Another requirement is a reliable car, particularly if you are a freelance; there is a limit to the number of times you can tell a picture editor that you can't cover something because your car is on the blink again. If you get on the staff then you may possibly get a company car (because of costs it will probably be at the smaller end of the range). Directors who only drive back and forth from the office are given large comfortable cars, suitable for driving long distances, and the people who clock up the most miles get the little ones.

In some ways, the photographer's car becomes his office. He will keep in it stocks of film, sets of steps, extra wet weather clothing, and extra equipment which may be needed but which is too heavy to put on his shoulder. (Incidentally, I know several photographers who have permanently strained either their shoulders or their backs through carrying heavy bags of equipment around. It's worth having a check-up from time to time to make sure you don't do the same.) These days most staff photographers have cellular telephones in their cars. Sometimes these can be taken out and carried on to the story, and the photographer and the office can keep in touch at all times. This way, the Desk can check on the progress of the story, and the photographer can call for reinforcements, or co-ordinate with the Desk for the collection of urgent film by motor-cycle messenger.

At the Scene

Before leaving, you should be armed with a good atlas or street map of the larger cities. It seems a small point, but you will probably be operating in a strange town and you will need to keep all your efforts behind the camera, without getting too worked up over finding the location of the job.

On arriving, if the job is a running news story then you will

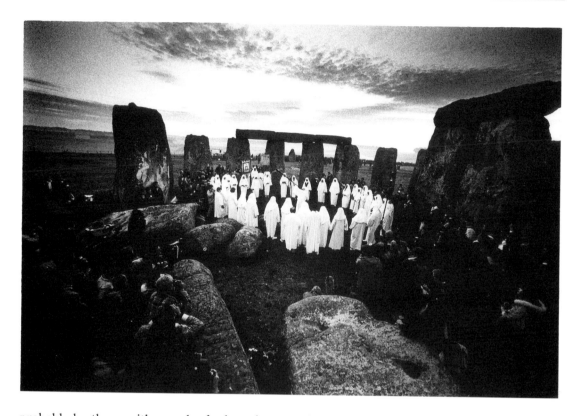

On location at the summer
solstice, Stonehenge, 1987.
BRIAN HARRIS

probably be there with a pack of other photographers. Don't park your car where it will be easily blocked in. Remember that, having got your pictures, you won't want to sit there for half an hour before you can set off for the office with your precious films. Even if you park well back and have to walk for a couple of minutes, it could save you a lot of hassle later. On some events, such as sports matches, unless you can be sure of a good spot you shouldn't even take the car if you can help it. Usually, there is a good public transport system to sports grounds and, again, you could be stuck in the traffic for hours after the game. Just select what you feel you need for the job, pack it into a small shoulder bag, and catch the train.

If the job involves taking photographs at the scene of a disaster, or if there are emergency services present, never, ever, block their access with your car. The obvious reason is that they may need to get injured people away from the scene

quickly, or to get special equipment in, but you should also remember that, if your car is in the way, it will be moved by whatever means are available in order to clear the road, and that may result in damage to the vehicle – speed will be more important than chips in the paintwork. Try if you can to park well away and hitch a lift, if you can get one.

Generally speaking, the police are quite strict on these occasions. You will be kept well back for a considerable period of time by a constable with orders not to let anyone at all past him. Tempers will fray as pressure is put on him by the growing band of photographers and television crews for access, and he will get the sergeant along to inform the assembly that they could be arrested for obstruction. This is par for the course, and I still do not understand why, after all these years, some police forces think they are in opposition to the media on this type of story. The media are there to record an unhappy event; like the police, they are there because they are doing a job. Most large forces at least have liaison officers for the press now, and they soon arrive on the scene; but even they get a hard time from the officers.

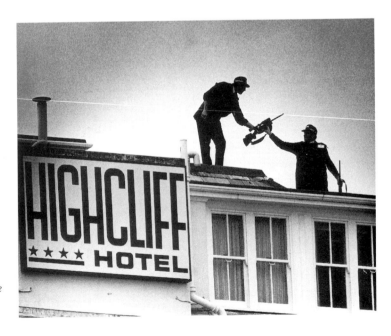

Police work: security precautions at the Tory Conference in Bournemouth on October 6, 1986 – the day before the launch of *The Independent*.
BRIAN HARRIS

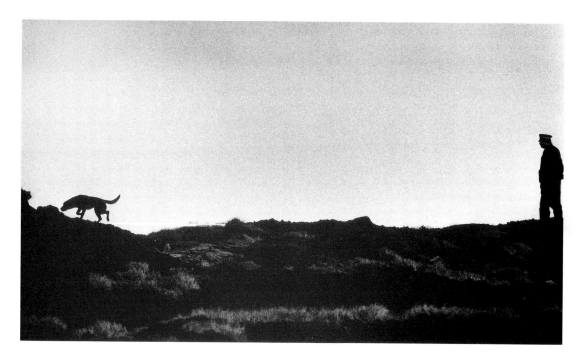

Relations with people generally are very important to the news photographer, and one of the main attributes that he needs is an ability to talk freely with people at all levels. You should never be intimidated by people of great wealth or social standing. One day you could be inside Buckingham Palace or Downing Street in the morning, and on a building site swapping stories with the brickies in the afternoon. A sense of humour is useful as tense situations can usually be eased with a joke. A kind word or a tactful approach can very often be more successful than a bluster or a threat.

Having got into a situation you must always remember that you will have to get out – again, humour or a genuine respect for a person will help you. In a street riot it is far better to back gently away from a confrontation than to escalate it by your presence. You must also be aware that you can sometimes become the victim of 'playing for the camera'. In public order situations, the police will often attempt to move you on, saying that you are inflaming the problem with your presence. You must be guided by your own sense, and, primarily, watch

Police work: the search on Saddleworth Moor, 1987.
JOHN VOOS

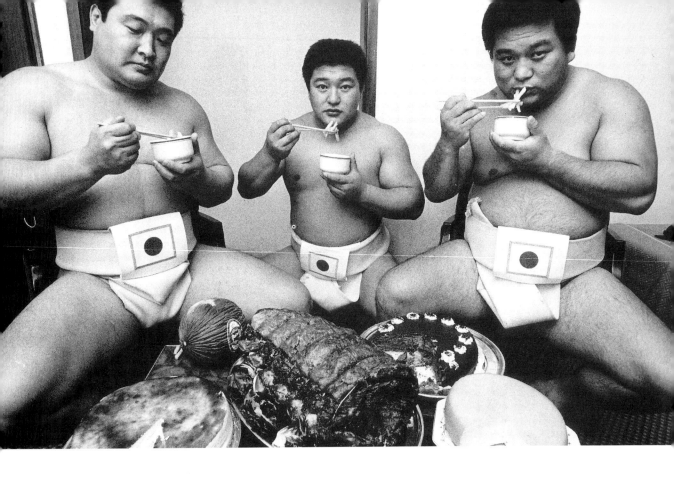

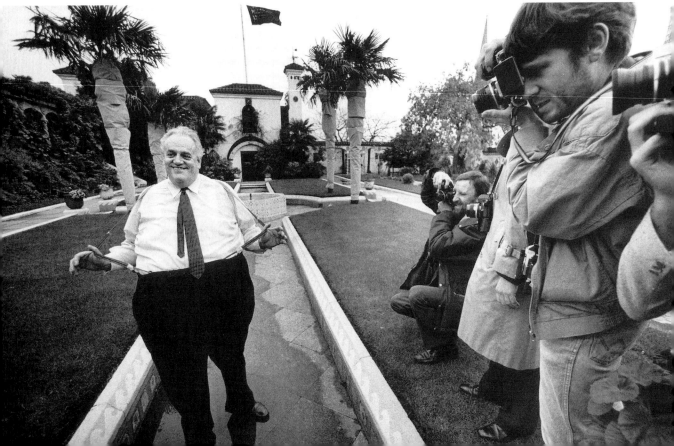

for your own safety. In these situations don't burden yourself with too much equipment. You mustn't carry more than you can afford to lose, and you must be able to run at a reasonable pace with it.

Not all is doom and gloom and there will very often be a pleasant side to the work. Don't forget that if you are the recipient of a great deal of hospitality, it will not only be difficult to focus, it will also be illegal to drive. Don't drink too much wine before the assignment is over – before you know it, you won't need to drive any more, not for your job, anyway. If you cover two or three receptions in a day, it's very easy to end up the worse for wear after the first one.

Opposite above Photographing people: the first Sumo wrestlers ever to demonstrate their traditional sport in Britain, at the Wembley Conference Centre, October 1986.
SURESH KARADIA

Opposite below Photographing people: Cyril Smith models men's shirts on the roof of Barkers in Kensington.
BRIAN HARRIS

After the Shot

Once you have taken your pictures, how do you get them back to the office? The simplest way is to get into your car and drive back, or, if you are on a story in a large town or city, you could send the film complete with captions back to the office on a motor cycle, returning yourself later in the day. If you are many hours' drive away, you may have to send the picture down the telephone line to the office by using a wire machine. These come in two versions – those that transmit from a print, and those that will send from a negative. In principle they are roughly the same, each using a source measuring the density of light in the image and converting it to a sound tone. This is then transmitted down a telephone line, and the process takes place in reverse at the other end.

With the print system a small print (usually an 8×6) is clipped to a circular drum, the machine is switched on, and the drum rotates once a second. This transmits a pulse down a telephone line so that a similar size drum with a piece of bromide paper clamped to it in a light proof case is rotating in time. On the transmission drum, a pin-point of light is shone on to the print. Attached to the light is a photoelectric cell which measures the amount of light reflected off the print – in dark patches there will not be much reflection and in light patches there will be more. The light is shone on to a white patch of the print, and the machines are set up electronically

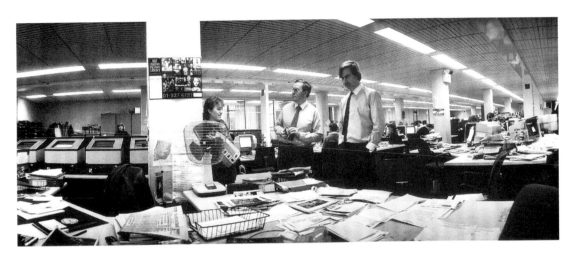

The picture desk at *The Independent*, showing Frances Cutler (Picture Desk Assistant), Alun John, and Chris McKane (Deputy Home Editor). Note the bank of receivers (left) for wire pictures from agencies and our own photographers.

to reproduce the same densities. The drums are rotated, and at each revolution the light is moved down a fraction of an inch, producing a line that is similar to the line on a television screen, consisting of a series of light and dark sections. The cell converts the light into electrical impulses that can be sent as sound down the line to the other machine, where a cell completes the reverse process and turns the sound into light, shining it on to the bromide paper.

When the whole print has been scanned (in around eight minutes), the machine stops automatically and the print is processed, again automatically, inside the receiver. A bromide print then drops out, with lines that are hardly visible to the naked eye. Using this system some loss of quality is experienced, but frankly, by the time the print is reproduced, it's hardly noticeable.

In the old days of Fleet Street, you had to assign a photographer to take the pictures, a darkroom printer to make the print, and a wire technician to send the picture if you wanted to use this system – this tripled the cost of covering any assignment by wire. The best line to the office was usually secured by the Post Office laying on a special point (known as a 'local end') for the machine to be connected to in the field; the connections back to the office would then be made. This would take some time, involving two operators and an engineer, and there would inevitably be a twenty-minute

delay before transmission could start. Now it is possible to connect the transmitter and receiver by ordinary telephone wires (using what is basically a computer modem), thus saving a great deal of time and unnecessary expense with the Post Office. Most pictures have been sent this way since a British Telecom strike took away the booked line facility – everyone discovered that they didn't need it anyway and that they could do things more quickly and cheaply by themselves.

These days we also have much more technically advanced machines which will transmit a picture off a negative, without the need for a print to be made at all. The ones we use at *The Independent* are made by Nikon, and cost about half a wireman's salary for a year. It works by placing a developed negative in a carrier, and using two cursors to blank off the section to be printed, rather like the masking frame in the darkroom. The machine is connected to the office via a Mercury telephone. We find this gives a clearer signal, and it also has the great benefit of the calls costing thirty per cent of those on the British Telecom system.

A laser beam scans the negative in much the same way as the other system. It converts the light into sound, and at the other end a laser beam reacts to the impulses from down the line by heating up a point on a sheet of heat-sensitive paper. It takes around five minutes to scan the negative, and the results are far superior to the conventional wire machine. The cost savings are significant – we only have to send a photographer on to a story, thus keeping down overheads. He usually works from a hotel bedroom, processing in the bathroom (which generally has no windows), using a changing bag. The film is dried using a hair drier, the negative selected and the telephone connections made, and, with luck, we have a print five minutes later. If there should be any blemish, we merely dial the line again in the hope of less interference.

We have used this system very well from as far afield as Iceland (where John Voos covered the Reagan–Gorbachev meeting) to the Zeebrugge disaster, where John and Brian Harris wired the tragic images direct from a hotel bedroom. We have also used the machine from the USA, where sports photographer David Ashdown covered the Ryder Cup golf. We found that we were able to beat our rivals day after day

Opposite above Pictures from
abroad: meeting of world religious
leaders in Assisi, Italy.
BRIAN HARRIS

Opposite below Pictures from
abroad: London taxi drivers took
Chelsea pensioners back on a
sentimental trip to Dunkirk. Taken
in the driving rain this picture
moved a great many of our
readers to write and phone
praising it.
SURESH KARADIA

with our on-the-spot coverages. Brian Harris has also used it
for his coverage of the US Presidential elections.

Nikon also make a machine that will scan a colour transparency through the three masks – magenta, yellow and cyan –
needed to make colour separations for printing. It then sends
them down the line automatically one after the other, giving a
set of colour separations in the office in twenty minutes.

I would defy you to tell the difference between some of the
material we have used in *The Independent* from the wire
machine and the pictures taken from an original. The results
are very clear, and any fault in the negative can be corrected
electronically. In case you wonder about our reception
facilities, the pictures can be received by anyone who happens
to be free, either a picture editor, or a secretary – the system
really is that good.

Another easy way to get your picture back to the office is to
use the Red Star service on British Rail, most cities being
connected to London by fast and frequent trains. The system
works fairly well, although if the material is vital we
sometimes prefer the photographer or an assistant to get on
the train themselves to make absolutely sure of a safe
delivery. Also, the network of buses on the motorways offers
a reasonable alternative, if the photographer calls the office
with the arrival time so that they can arrange collection at the
London end.

From overseas, the film may be airfreighted back, and most
papers have an agent at Heathrow to collect the packet.
Sometimes it is possible to ask a passenger to carry the films
back, but nowadays, with worries about drugs and security,
this is not so easy.

When you send your unprocessed film (by whatever
means), do keep them in their plastic boxes. If they are
dropped, the ends can come off the cassettes and the film can
be fogged – an expensive mistake. I remember once opening
a packet from a photographer we had sent to Texas, when I
was on *The Mail on Sunday*, to discover that the ends of one
of the cassettes had come off in transit, and he had lost the
results of a whole roll of film. Since we had spent thousands
getting him there, I thought it not unreasonable to expect to
see all the pictures he had taken. Overseas it is also possible

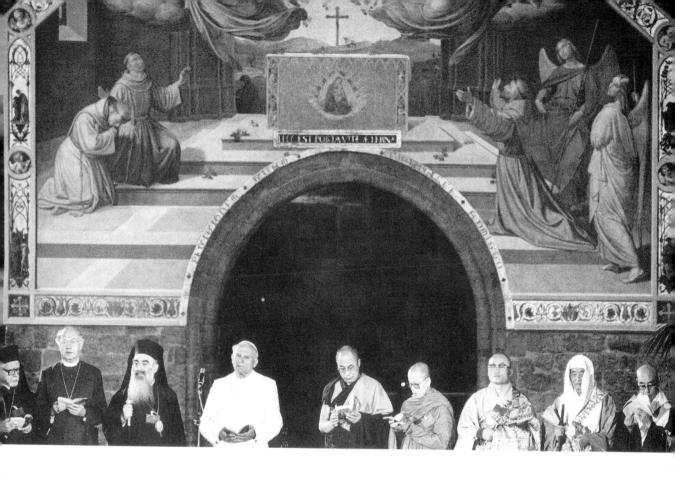

Opposite above On the road:
David Steel asleep on his Battle
Bus during the 1987 General
Election campaign.
BRIAN HARRIS

Opposite below On the road: in
my opinion this was the finest
picture taken during the 1987
General Election campaign.
Coming as I do from South Wales
this picture says much more for
me than might appear at first
sight. The street is made up of
some of those thousands of houses
that litter the valleys of South
Wales. They are built from the
same shade of stone blocks, and
one or two, like the houses on the
left, have been improved with
aluminium windows. The corner
shop on many similar streets has
closed, just like this one. There
are always one or two for sale,
often for the price of a new Ford
Sierra. The people who live in
them are mostly middle-aged and
their cars are not very new and in
need of repair. At the bottom of
the street is a glimpse of the
valley bypass road which makes all
the valley towns into quiet havens
for the children to play in. Beyond
the road is a factory, built from the
inevitable corrugated sheets,
probably packing cardboard boxes
or vending-machine cartons. There
is a farm just hanging on beyond
the factory, and the slopes of the
valley in the foreground are in fact
landscaped slopes of a coal tip
planted with conifers. This is the
South Wales of my youth, and I
could point to a hundred towns
that are like this particular one in
Neil Kinnock's constituency.
HERBIE KNOTT

to go into the office of one of the international agencies, and to
use their facilities to wire a picture back to their London
office. Alternatively, you could go into the offices of a large
paper in the city where you may be.

Printing in the Darkroom

In the field, then, the first thing that a photographer will do is
forget everything he ever read about processing and printing
technique in his *Boy's Book of Photography*. If we did
everything strictly by the book we would never produce a
newspaper on time at all. We can't afford the niceties of stop
baths and various specialist developing techniques. Time is of
the essence, and, while not wishing to sacrifice quality unduly,
a reasonable compromise must be accepted.

Most Fleet Street darkrooms turn film into prints in well
under an hour – there isn't much slack time. Typically, four
films will be processed together in deep tanks, and after
developing a rinse will be given before fixing, again in a deep
tank, and very strictly for twice the clearing time. Another
brief wash, and then the prints are rinsed in wetting agent or
methylated spirit, and rubbed down with a damp chamois,
before being hung up in a warm cabinet. The drying takes
about five minutes, and the film is then contacted or, if time is
short, viewed as negatives on a light box. A selection is made
and the negative is placed in the enlarger. Test strips aren't
frequently done – we usually rely on experience. Prints are
normally made on resin-coated multigrade paper and
processed in a 'dry to dry' processor – our Ilford model takes
fifty-five seconds from one end to the other. Sometimes a wet
line will be set up for something really special, but most times
we use the machine.

In the darkroom at *The Independent* we have four excellent
technicians, and either they, or the photographers
themselves, will make the print. In some Fleet Street
darkrooms photographers are not encouraged, and in one or
two they are not even permitted. They just post their
contacts through one flap and get the finished prints back
through another.

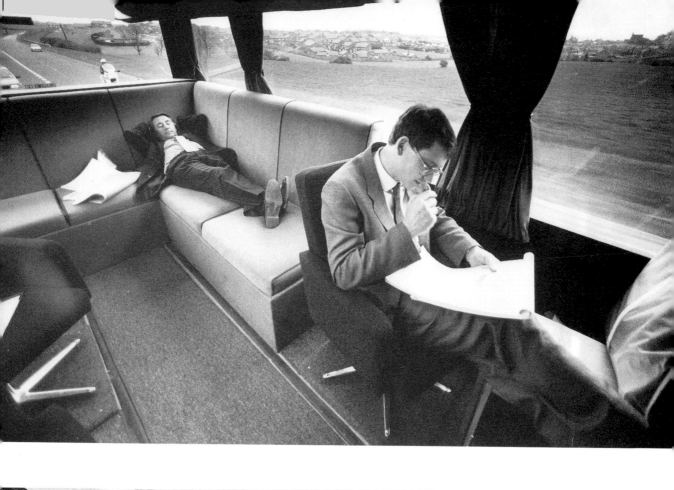

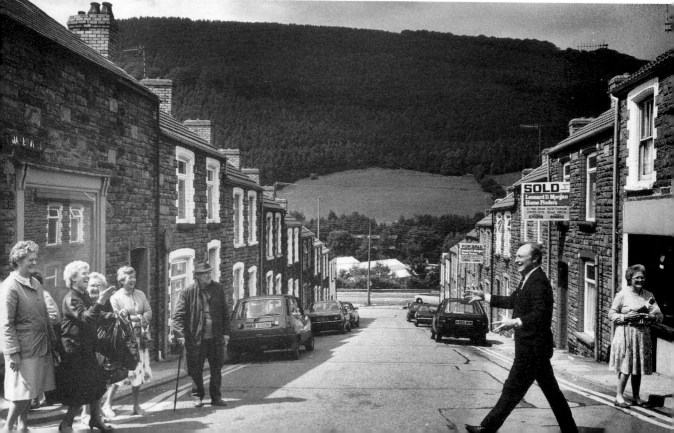

Competition and Camaraderie

However, it is a long way to this stage from getting the actual picture in the first place. It is important to have a degree of common sense on the road, and you never really stop learning. Although you may have covered one type of assignment many times in the past, each is different, and each presents a new set of challenges and opportunities. It is essential to keep your wits about you, and while you may see that others are laughing and joking and having a bit of fun, you can bet your life that they haven't taken their eye from the ball for a second. Don't let your guard slip for a moment – these people are professionals, they have been doing it a long time and you are in the most competitive atmosphere in the world. Friendships will mean little when you come face to face with

On the road: Dr David Owen in Salisbury during the 1987 General Election campaign.
BRIAN HARRIS

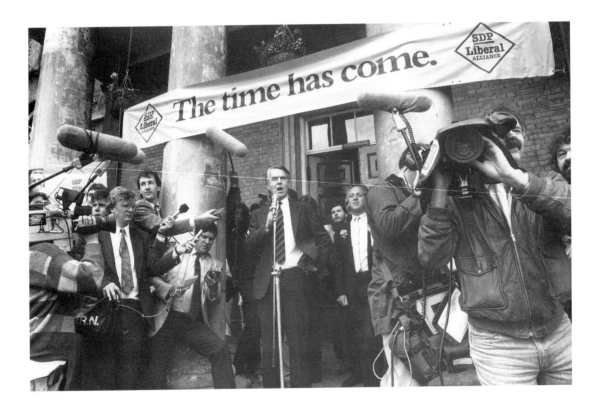

an opportunity to score a point, and, although photographers may be friends before and after an assignment, they are in direct competition when they are at work. They will all exploit a newcomer, so be wary. Of course, some will be friendly and helpful, while others are stand-offish, but this is true of all professions.

Margaret Thatcher in Middlesbrough during the 1987 General Election campaign.
JOHN VOOS

If you are fortunate enough to gain an exclusive, remember the words of the wedding service and keep it 'only unto you'. There is no such thing as a shared exclusive – it's like being 'slightly pregnant'.

Having dwelt on the competitive nature of the profession, it would be very wrong not to highlight the other side. If you can get in, you will be part of a very select group of people who travel the world in search of news. You will be able to walk into the bar of a hotel in a strange country in the middle of a news story, and instantly find some friends and colleagues, who, if not really helpful, are at least in the same boat as you

A moment captured: Mrs
Thatcher in Norfolk during the
1987 General Election campaign.
JOHN VOOS

are, and will, in times of danger, stick closely with each other.
They will exchange rolls of film, confirm captions with each
other, share cigarettes and bottles of Scotch, phone numbers
and cars, but they will *never* share exclusives.

In what some would call the 'good old days', a *Daily Express*
man found himself with a major exclusive in an African country
a day ahead of his deadly rival from the *Daily Mail*. Having got
the pictures he found the only wire machine in the country and
wired his exclusive to his paper. He then waited to see his
rival turn up a day later and even directed him to the wire
point before leaving for the airport. He was airborne and
enjoying a well-deserved drink when he suddenly
remembered that he still had in his pocket a valve from the
wire machine, without which it was rendered useless for his
rival. To be fair, when the two met up in London a week later,
he did give his pal the valve just in case he should ever need
a spare!

Things haven't changed that much, and rivalry is still there
between photographers for that greatest thing in newspapers
– the exclusive.

Day to Day in the Provinces

The traditional route to Fleet Street starts in the provinces. Weekly papers are the time-honoured training ground for photographers and, although there are some excellent courses available in colleges around the country, frankly you can't beat 'hands on' practice. The route usually followed is from weekly to evening, and then to daily, with perhaps a side trip to a provincial news agency working for national papers. While it is possible to break into Fleet Street in one go, it's unusual.

So let's set off on the road and see what each stage of the journey looks like.

Busy Days on a Weekly

The *Bracknell News* is published in a busy and prosperous town in Berkshire, and is typical of a weekly paper with a little life in it. It covers the usual range of events, from charity presentations and local sport, to the odd Royal event in the surrounding area.

The Chief Photographer is John Curtis, thirty-one, who's in charge of himself and a junior. Their office is in a factory unit on the edge of town, slotted in among the light industry which Bracknell attracts. This is a sensible trend among newspapers, many of whom have forsaken expensive town centre offices, moving to where the floor space is cheaper and the parking easier, for staff and visitors alike. John has a darkroom next to the news room, with a couple of enlargers and a range of sinks with developing trays. They use resin-coated paper, and have a small drier rattling away in the corner.

John Curtis of the *Bracknell News*.

Opposite above Geronimo! A child at playschool enjoys a new experience.
JOHN CURTIS

Opposite below Ice One Cyril! A well-deserved break in a busy schedule.
JOHN CURTIS

The paper covers Ascot and Wokingham as well as Sandhurst and Crowthorne and this is a busy news area as well as an expensive one for housing – there is a problem in attracting staff who cannot afford to buy houses in the area. Weekly papers are usually small businesses and the salaries are by no means generous.

John's interest in photography started at school when his older brother in the Navy came home with glittering new cameras and lenses from Hong Kong and the Far East. John was rather taken with the opportunities that this new equipment opened up. He became an industrial photographer with a large company, was soon very proficient in studio techniques, and gained confidence in his ability generally. After a few years, though, he realised that the work did have a certain regularity to it, verging on monotony, so he looked to the press world for some variety. He joined the *Bracknell News*, his home town paper in 1985. Now he works with five reporters and is busy every day on a wide range of assignments, far away from his previous job photographing machinery in a studio.

A typical day for John will show just how hard the work is on a local paper. He works every other evening and alternate weekends, taking time off by arrangement with his Editor. So let's follow John around for a weekend to see what he gets up to.

The first job on Saturday morning is at 9.30, and involves getting together a sports delegation which is visiting from Bracknell's twin town in Germany. Inevitably it runs late – these things never take place on time – leaving John little time to make the start of a sponsored charity walk at 10.30. It's actually started when he gets there, but he catches some of the walkers up along the route and grabs some shots on the street.

From there he goes back to the Sports Centre where another charity event, this time a hockey marathon, has started at 11.00. He manages a few frames here and then moves on to a local Scout Summer Camp where he makes a start on the spread of pictures his Editor wants for next week's paper. Just time for a burnt sausage and some beans off the barbecue fire before he's off to Binfield Cricket Club,

where he needs to pose up the new team playing their first game of the season. After a bit of banter he arranges them neatly in front of the pavilion, and makes certain he gets all their names right for his caption.

If you're getting tired, thinking that five assignments in one day is hard going, don't even think of a break because it's now he has to start to get busy. In the next two hours he has to get around five (yes five!) garden fêtes and parties. He starts in Bracknell town and then goes to the Fun Time Fayre in Sandhurst; from there it's off to Crowthorne and then back to another fête at a church nearby, and then finally on to Warfield for the last fête of the afternoon. There's time for three or four pictures at each, checking the names carefully, before

diplomatically fending off the raffle ticket sales and charging on to the next venue.

Now you might suppose he can stop for a breath! But no. Remember the new cricket team six assignments ago? Well he now has to go back and grab one or two shots of the team in action for the sports pages; and while he's in a sporting mood, he fits in a look at the Bowls Club for some gentle action taking place there.

Now it really is time for a break and John pops home for a sandwich. It's not a complete rest though, as he checks through his growing file of captions. He has a neat system for these, using one page of his notebook for each job, and taking a frame of the school or church where the event is being held at the start of each set of pictures – that way he doesn't get St Michael and St Mark mixed up.

Time now for a spot of television or a drink with friends? Not likely – there are still two more to go! A party of very ill children is being taken away for a holiday cruise on the QE2, and there's a meeting at a local hotel to announce the plans. After a few pictures here, John sets off for the last job of the day, a party at Sunningdale given by the local Conservative Association.

He gets home at 10.00 p.m., doesn't feel much like going out, and he goes to bed. Sunday dawns and the prospect of washing the car, having a pint at the pub, and a roast beef lunch seems inviting, but John still hasn't finished. He has to go to a swimming gala at the Sports Centre and then back to the camp-site to take more pictures for the centre spread. Sunday lunch is another burnt sausage and more beans!

Then he goes into the office to start processing and printing his weekend work. This takes a couple of hours and he tries to produce a selection of two or three prints from each job to give a choice for the page design. There are no darkroom staff to help and he does the lot, finishing by filing the negatives for future reference.

On Monday morning he's in bright and early at 7.00 a.m. to caption the prints. He has thirty to forty 10×8s to caption and he usually writes the information on the back of each in biro.

Adrian Seal, the Editor, gets in at 8.00 a.m. and starts to lay the paper out. He works closely with John after asking his

advice over the choice of a certain picture or checking the spelling of an unusual name with him. The layouts have all to be completed by 1.00 p.m. in order to meet the deadline for the printing of the inside pages.

On Monday, John is always looking for a news picture to make the front page and he talks to all the reporters to see if they have anything to go on. He learns this week of some vandalism in the town centre and pops out in his lunch hour to take the pictures for page one.

So it's a busy life on a weekly, but does John enjoy it?

'Certainly,' he says. 'It's never the same two days running – the variety is fantastic. One minute I'm doing portraits or fashion for a feature, the next a sports assignment. I can't think of any other branch of photography that gives that.'

His favourite assignment is photographing children, and he specialises in grabbing candid shots that sum up a child's feelings. He has strong views on different aspects of the life – indeed, it is a way of life, and not just a job of work.

He is not obsessed with equipment, feeling that it's the photographer and not the camera that makes the pictures. Like many pros, he started off with good quality second-hand gear. He says that one of the greatest gifts a news photographer can have is the ability to get along with all sorts of people, quite literally from dukes to dustmen. In photographic terms, he advises people to take careful note of the backgrounds in pictures. Too often, he says, the right subject is placed against the wrong background, and the effect is rather messy.

Like all photographers, he likes to see his name in the paper, but he points out that this can work against you – if it's a poor picture, then everyone knows it's you who's boobed. All the more reason, he says, for trying hard on every job.

Don't go into weekly newspapers to make a lot of money, unless you own one! The salaries are not as high as you may think, although sometimes little perks like the use of a company car can add a bit. Also, on a practical note, don't forget it's an outdoor job. You will get wet and cold, and a fairly stout constitution helps, as well as a set of good waterproof clothing.

As we've seen earlier, it's not uncommon to cover fifteen

to twenty assignments in a couple of days, so you shouldn't be afraid of hard work. He also thinks, quite rightly, that the darkroom side is as important as the actual picture-taking, and that a bad print can ruin a good picture. He feels that you should get as much satisfaction from making a good print as from taking a good picture, and admits to a tingle of pleasure seeing a good print coming up in the dish. His own darkroom, though small, is adequate and he has three enlargers and a beautiful set of home-made 'dodgers', lovingly fashioned from cardboard boxes with holes in and bits of coat hanger bent into shape.

He also stresses the importance of giving plenty of thought to a picture and never dismissing an assignment too quickly. You can, he says, always think up a better way to do something in the car on the way back; far better if you can manage that thought on the spot!

He thinks that, for beginners, the sheer volume of work, along with the long hours could be daunting, but frankly there's no better experience to be had.

John's work in the area often takes him on to Royal stories (being not too far from London), and it's a part of the work he enjoys. It inevitably brings him into contact with the Fleet Street 'pack', who he enjoys working with and tries to help if he can.

Like all of us he's had a few failures. His best, he says, was when he took a picture of a whole group of local celebrities using the wrong flash synchro on the camera, and ended up with a perfectly exposed half negative of their trousers and no top halves! 'You make your mistakes just once,' he says; 'you profit from them and you don't look back.'

He also enjoys finding his own stories, talking to friends and meeting people in the local pubs, an invaluable source of stories. This, incidentally, is what the Editor loves to see – a steady stream of off-beat or unusual stories to brighten the pages, and to get away from court cases and council meetings.

So would John change his lot? 'Yes and no,' he says. He would really like his own photographic business working, he thinks, not only for newspapers, but for anyone that appreciated imaginative photographs. But newspapers would never be far away. His job gets him to places he wouldn't visit

as a studio photographer, and this, with the challenge and variety each assignment brings, keeps him very happy – if on occasions he is perhaps a little too busy.

The photographers on weekly papers fall into two categories – young people using it as a training ground, and others who are more than happy to stay at that level. There are many excellent photographers, both creative and technical, on weeklies around the country, and the circulation of the paper should never be seen as a measure of its photographer's abilities.

The next step along the road may well be to join an evening paper in a large town or city.

Evening All!

The *Birmingham Post* and *Mail* complex actually houses a complete collection of papers in one building. They combine a string of weekly papers (some paid for, some free), a busy evening paper with a great many editions for local areas of the West Midlands, a regional morning, the *Birmingham Post*, and a Sunday paper, the *Sunday Mercury*.

The papers are housed in a 1960s glass and marble block at the centre of Birmingham looming over that concrete and untidy urban sprawl that is the West Midlands. The entrance foyer is busy, with a steady trickle of readers placing ads and buying calendars.

The newsroom is a big, square, open-plan office with ranks of the now almost obligatory VDUs with their green blinking eyes. The Picture Desk is a few feet from the main News Desk and within a shout of the sub-editors. The Picture Editor is Trevor Roberts, who is in charge of a team of sixteen photographers who work for the *Mail*, the evening paper and and the *Birmingham Post*, the morning paper. He is also in touch with a further five photographers who work for the string of weeklies. The photographers will work from their head office in Colmore Circus for either the morning or evening paper, depending on the shift they are working. They will sometimes work for both, having to find two different pictures from one assignment. They work eight-hour shifts on

a six-week rolling rota (making their social life a little more regular), and they will also have to work some weekends in their nine-day fortnight working pattern.

The key word on an evening paper is 'speed'. All the photographic corners are cut in the rush to produce a picture for the evening edition. The day starts early. Around 7.30 a.m. Trevor Roberts will already be at his desk having read the papers and listened to the radio news on his way in. He will speak with the News Desk and most mornings he will send off a couple of photographers straight from their homes to save time. Trevor tends to be a little independent of the News Desk, who will think of stories only in words terms. Decisions on pictures for that evening must be made quickly, so Trevor will often make up his own mind on picture potentials, rather than wait for the News Desk to alert him. Reporters and news desks can always catch up on a story; photographers can't. If they aren't there they just don't get the picture.

Allowances also have to be made for travelling time to reach stories. Very often a photographer can save a few extra minutes by using a favourite short cut to avoid the city traffic.

Gone are the days of following fire engines, and most fires have to be fatal or spectacular to warrant coverage. The deadline for the first edition is 9.00 a.m., which means that a photographer will have taken a picture, and processed and printed it before most people have reached their offices to start work for the day. All the photographers have bleepers to alert them when they are needed, and if they have time they will call in from the scene and tell the desk of the worth of the pictures.

Once back at the office a photographer will park his car in the underground garage and go straight to the darkroom. The film will be processed by a continuous processor – it goes in at one end and comes out fixed and dry at the other. This takes five to ten minutes, depending on the rating of the film, and the speed that the film passes through can be regulated to give a longer time in the developing bath. Once processed the film is passed frame by frame through a video link to the Picture Desk, where a screen shows it as a positive image. Over an intercom the duty Picture Editor will tell one of the

nine darkroom technicians which frames he wants printing up into 10×8 prints.

While the prints are being made the photographer will type out a complete caption on a three-fold caption pad in the photographers' room.

The prints are processed in an Ilford processor which takes two minutes to dry on resin paper. The darkroom is spacious and has a dozen Ilford enlargers. This may sound extravagant, but when three or four photographers arrive together their negatives can all be printed at once on different enlargers without delay. The most precious thing on an evening paper is those few seconds saved in the darkroom. Test strips are rarely made, and the experience of the printers means that a second sheet is almost never needed.

The photographers have their own room off the darkroom with lockers for their equipment and personal belongings. Each photographer is provided with a bag, two Nikon bodies and three lenses. They have a large and small flash gun and a tripod. There are also a couple of longer lenses in the cupboard for the times when a 300mm or 600mm lens may be needed. They provide their own cars, and are paid a mileage allowance when they use them on company business.

During the main part of the day around six photographers will be out and about in the *Post* and *Mail* area, which stretches from Stafford and Stoke in the north, down to Cheltenham and Tewkesbury in the south. Not all will be doing news jobs – some will be shooting features or specials for other sections of the paper. They will need a different approach for the evening and morning papers. The *Post* will like to have something perhaps a little more thoughtful than its sister evening paper.

The work pattern also includes one night a week on a late shift, starting at around 1.00 p.m. or 2.30 p.m. and finishing up at 11.00 p.m. at night. Sometimes the photographer will be covering a news job for the morning paper, or perhaps two or three evening functions for the next day's evening paper. Most days they will cover four or five jobs each, the daily round being mostly local functions, charity presentations, golden weddings, and social events in the evenings. Accuracy with captions is essential as readers will be quick to complain

of a wrongly-spelt name or incorrect detail.

By lunch-time each day the major part of the assignments will have been covered for the evening paper. The paper must be printed and bundled by mid-afternoon in time for the vans to deliver to newsagents by early evening to catch the readers on their way home from work.

On Saturdays there is a pink sports special, and for a picture in the edition a photographer will have five minutes at the match to grab a couple of action shots, and will then race back to the office. On a really dull day in the middle of winter he'll probably only have time for one or two frames before leaving to spend a couple of extra minutes in the developer, forcing the last ounce of speed from the film. When working this close to the deadline, a failed traffic light on the way can mean the difference between getting a picture in the paper or in the dustbin.

Prisoner protest. An escaped prisoner threatens an ambulance man. This picture, taken with a Nikon F3 on 300mm lens using Tri-X film, won a news picture award.
JOHN JAMES

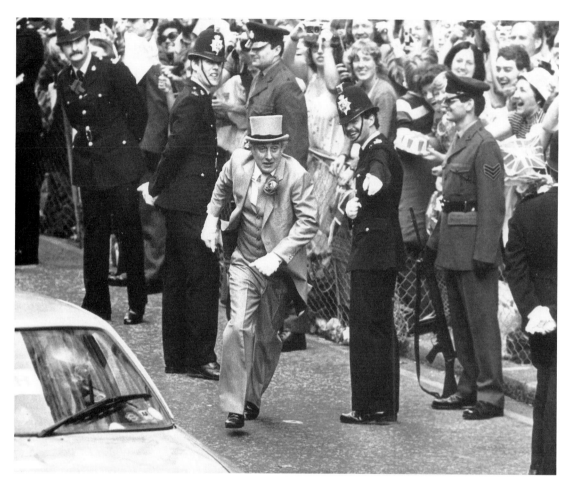

As well as the photographers based at the head office there are a couple based in outlying district offices. John James covers the south of the circulation area from his base in Redditch. He's a local boy, having joined the *Post* and *Mail* after seven years on the weekly in the town. He knows the area and its people, and is well placed to provide the three pictures a day that he needs to fill his particular edition. He works with a couple of reporters, but they are often tied up with stories that don't produce pictures and he has to use his own contacts to find something to shoot. He rarely fails and Redditch life continues to get a fair show in the *Post* and *Mail*.

Get me to the church on time! Comedian Spike Milligan runs up to St Paul's Cathedral for the wedding of Prince Charles and Lady Diana Spencer in 1981. This picture was taken with a Nikon F2 on a 300mm lens using Tri-X film.
JOHN JAMES

John James of the *Birmingham Post* and *Mail*.

John enjoys the challenge of working on his own. 'I get a buzz from seeing a picture through from idea to publication,' he says. 'No two days are alike, and you can always expect the unexpected.' As well as maintaining a steady flow of pictures he must be on top of any news story as soon as it breaks, and he keeps in close touch with the emergency services in his patch, ever-alert to their movements. 'You have to be quick on an evening paper,' says John. 'You have to be able to sum up a situation quickly, get your picture right first time and get it back on time; it's no good having a great picture if it's too late to go in the paper.'

Phil Addis, a photographer at Colmore Circus, is still enthusiastic about evening paper life after twenty years in the Midlands behind a camera. He started work on a small weekly in Smethwick and progressed to the evening *Mail*. He still enjoys the speed of the work. 'It gets your adrenalin going better than anything I know,' he says. 'You can be at the scene of a major tragedy, call the office and tell them that you have a front page picture in the bag, and race through all the back streets you know. The darkroom will be waiting for you and the prints will be made when the film is barely dry. Half an hour later you can see your work on the front page of the next edition – it's still a great thrill.'

How does he feel about the seemingly endless round of charity functions and pictures of the Lord Mayor? 'It's a matter of attitude,' he says with a smile. 'You can go down the same road a thousand times but you still never know what is just around the next corner; it's always something different, always something new.' In some ways it could be easy to get swallowed up in a busy evening paper, working to tight deadlines to fill lots of space, but photographers with Phil's attitude will always be rewarded.

The evening paper photographer's first attribute must be speed and a complete mastery of the equipment and technique. There is no time here for beginners to try and learn. He must also be able to think quickly, summing up situations at a glance and not missing a vital picture due to lack of thought or a slipshod approach. Confidence in his own ability is also useful – there are no second chances; it has to be all right for that night!

Phil Addis of the *Birmingham Post* and *Mail*.

Left Family tragedy. The funeral of a Birmingham family who all died during a blaze at their home takes place at Kings Norton Parish Church during a blizzard. One of the saddest pictures taken by Phil Addis of the *Birmingham Post* and *Mail*.
PHIL ADDIS

Below One for the record books! Birmingham allotment gardener Henry Morgan with a pumpkin big enough to keep his family in pie for months – and an entry for the National Pumpkin contest. One of the happiest pictures taken by Phil Addis of the *Birmingham Post* and *Mail*.
PHIL ADDIS

If it's Wednesday, I'm from the *Daily Express*

Ask most people what a news agency is and they will probably reply it's the people who deliver the papers. In fact, an agency delivers the news to the papers, very often more quickly than they can find out about it by themselves. All around the country, indeed all around the world, there are agencies, ranging from one man in his attic specialising in one particular field, to busy agencies that employ teams of reporters and photographers to prepare stories and pictures for newspapers, magazines, television and radio stations.

Most large towns in this country have an agency. In the more rural parts of Britain the agency will perhaps be based in the county town, and cover the outlying areas. Some specialise in sport, others in court reporting, but most will tackle anything they can make a bit of money on. Unlike newspapers, which have a basic income from advertising and circulation revenue, the agencies have no income other than the money they can make on the strength of their stories.

Nestling in the Surrey hills is the town of Guildford. Largely a commuter town for London, about an hour away by train, it is a busy and lively source of news as well. It's in the prosperous South-East, and is a pleasant place to live, attracting many figures both from big business and show business. It is the home base of Southern News Service, or, as it is universally known in newspapers (by the name of its two founders), Cassidy and Leigh.

The agency is housed in a converted mill building straddling the River Wey, passing through a valley on its route to Weybridge and eventually the Thames. The office is two minutes from the busy A3, five minutes from Guildford, thirty minutes from Heathrow Airport and forty from Gatwick. It's also twenty minutes from the M25 and has easy access to the motorway system.

It's an agreeable spot to work, with views of the river from most of its windows for those who have time to pause and seek inspiration. The main floor is rather like a complete newspaper in miniature; indeed, some weekly papers do not have the same amount of space. There is a main room with

Don Leigh and Denis Cassidy of
Southern News Service.
MARK BAKER

reporters' desks and phones, a darkroom complete with colour line, and a small studio. They also have the latest in technology, each reporter having a lap-top computer capable of filing stories direct into the office telephone. After editing, these stories are filed to newspapers, either by telex, or (increasingly) straight into the newspapers' own main computers. There is also an office for the two men who started the business, Denis Cassidy and Don Leigh.

They knew each other at school in Manchester and Don left first and joined the local paper. Denis was taken with the idea of journalism as well, and started on the weekly paper circuit in Irlam in Lancashire. He went on to Fleet Street and the *Daily Sketch* and *Sunday Pictorial*. He covered a full range of events world-wide, including the Russian invasion of Czechoslovakia and Ian Smith's UDI in Rhodesia, and travelled extensively in America, Africa and Europe, covering everything from human interest stories to full-blown wars. Don, meanwhile, was on the *News Chronicle* in the North, and progressing very well up the scale.

Denis hankered after setting up an agency himself. He was

offered a chance with an agency in the North and was told that his first task would be to get rid of a reporter who didn't fit in. After making his way north, Denis was horrified to find that the target of his dealings was to be his old pal, Don Leigh! He quickly realised that, in fact, it was not Don who needed replacing, but the management of the agency itself. This achieved, the old pals decided they would come south and start an agency. Denis let it be known that the site would be at Aylesbury, and Don and his fiancée started looking for places to live. As a bluff, in case someone else wanted to queer their pitch, they let it slip that they would be moving to Weymouth to set up shop. Both being experienced in the ways of Fleet Street, they kept the Aylesbury cards close to their chests. In fact, Denis had been eyeing up Guildford as the spot to start, and hadn't even told Don, who by now had got quite far along with the move to Aylesbury. Denis rang him one day and arranged to meet in Guildford where he explained the whole plan to him. Don had done his National Service basic training in the area, and he didn't have fond memories of the place.

However, they agreed, and rented a cottage near the town as their first office. They quickly became busy and called in a photographer as and when they needed one. They soon discovered, however, that local commercial photographers were unable to take the type of picture required by the papers; neither could they produce them to the required deadlines. So they engaged their own photographer and have expanded steadily until today.

The agency now has a staff of eight reporters working in shifts from 7.00 a.m. until midnight, with four staff photographers. Through the years they have produced many photographers who have gone on to great things in Fleet Street. They cover everything within about a hundred-mile radius of Guildford, and have the deserved reputation of being one of the sharpest outfits in the country. They work on two basic premises – they never let anybody down and they never turn anything down.

The day starts at 7.00 a.m. with a reporter calling all the police offices, fire stations and ambulance controls in the area. This ritual ('doing the calls' as it is known) is repeated

religiously every two hours throughout the day, and provides a foundation of news to build on. Also there will be an amount of assignments already known about and logged in the daily diary. The early photographer will check with the office before leaving home and, if he is not sent straight on to a story, he will come in. After checking the darkroom, he may grab a cup of tea and read the paper to see if he has anything published that day.

Don and Denis will speak to each other from home and meet in the office at 9.00 a.m. Over a cup of tea they plan the day's work, assigning reporters and photographers, and discussing ideas and follow-ups on running stories.

A photographer's day will vary tremendously. Not being tied to one publication he will have to work in several styles, being the man from the *Express* in the morning and maybe

This man at Birdworld near Farnham in Surrey really believes in immersing himself in his work. Here he is collecting eggs from one of the many aquariums at the gardens, so that he can place them in special breeding tanks.
NIGEL FARROW

A couple in Oakhanger, Hampshire, bought what they thought would be their dream cottage in the country, only to find that after a few years this monster radar dome came along to overshadow them.
ROGER ALLEN

representing *The Independent* in the afternoon. He will work on specifically-ordered jobs for them, or on a story found either by himself or by others at the agency. Indeed, he might not even be working for a daily at all; sometimes he will be shooting colour for a magazine spread or a foreign paper.

Material will either be brought back to the office for processing and despatch, or it may be sent unprocessed by Red Star on the train to London. If it is urgent, a local courier firm will deliver the film by motor cycle direct to the London offices of the papers. On a major news story involving people who are not easily accessible, both the photographer and the reporters will immediately start to search for a picture already taken by a member of the family or a friend and arrange to borrow it. This is known as a 'collect' picture, literally collected from the scene. These pictures are valuable and very often can be the only source of illustration for a story.

Indeed, if the agency can secure the only copy of a picture of a much sought-after person, this can be sold either exclusively to one paper or offered at a premium price to others.

Most agencies strive for the big exclusive that can be sold to one of the tabloids. Depending on the contents, this can be worth hundreds, even thousands, of pounds. Very high standards are kept up by the agency – sometimes they may be involved in working on a story that a paper has exclusively. Under no circumstances at all would the agency break that story to anyone else – there is a bond of trust between paper and agency that is never broken.

Via contacts the agency will discover the whereabouts of a person in the news, whether politician, pop star or possibly even crook. If no one has seen or interviewed them, then the first talk or picture is a valuable property. After checking out the facts it may be necessary to stake out the house or hotel where the person is, watching it round the clock, in shifts if needed.

Sometimes an approach may be made to the person if it is felt that this may be productive. If, however, it is felt that any approach will be rebuffed then the picture will be 'snatched' at the first opportunity, possibly on a long lens or by stepping out into the person's path with just enough time to take one frame. Very often it would be easier for the person concerned to speak to one reporter and pose for one photographer rather than being pursued by the pack. Depending on the story, the agency may have pre-sold the results to one paper, or may wait until it's in the bag before deciding which would be the best and most profitable one to place it with (either a daily or a Sunday paper).

One of Cassidy and Leigh's best sources of stories comes from the large military population in the area, which includes Aldershot, Pirbright and Sandhurst. A steady stream of good stories comes from these places, and the soldiers know that Denis and Don would never abuse a confidence shared with them, or in any way distort stories. The Army produces good human interest stories, active news stories, and with courts martial, good crime stories from time to time.

During the build-up to the Falklands campaign, the agency

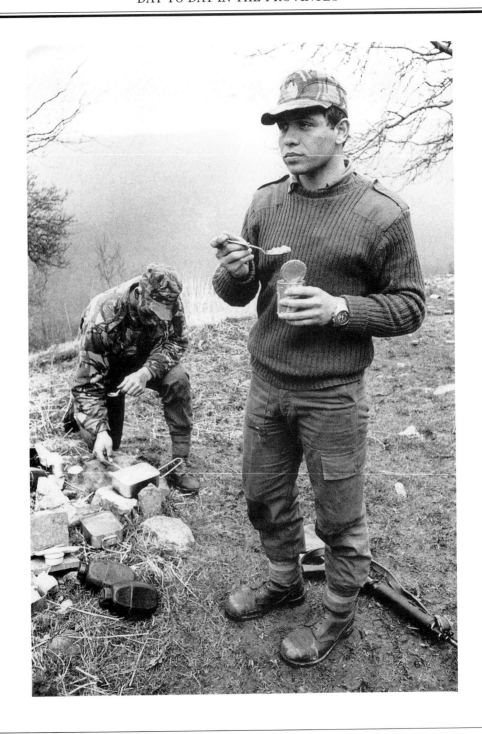

produced dozens of picture stories that made the nationals as the troops kitted up for action. Denis was even invited to fly out with 2 Para to the Falklands where it was felt that his fluent Spanish would be of use in interrogating prisoners. Although the regiment was keen, the Ministry of Defence felt that the action would not come to much and didn't think that it would be worth his while going! So Denis waved them off and the Ministry of Defence lost out on their Spanish speaker. Many of the regiments were photographed before leaving and carefully filed away. This paid dividends – when Parachute Col. 'H' Jones was killed at the height of the action, and subsequently awarded a posthumous VC, all the pictures you will have seen of him came from the agency files. This should not be seen as cashing in on a tragedy – far from it, it spared the family from being besieged by reporters and photographers for days. The agency reward came when Mrs Jones decided to speak of her feelings, and Denis was asked to conduct a moving exclusive interview with her and her family, illustrated with some touching pictures of their life without the Colonel.

But agency work is not all sadness. Very often, a touch of humour in a picture will help to sell it to a paper to relieve the daily diet of wars and politics. The agency photographer is always on the look-out for something different. For example, when the nationals send their own men to cover a story in the area, then perhaps local knowledge, or even a little old-fashioned cunning, may give the agency the edge.

Also, just by working faster than the staff man, the agency can sometimes get the pictures on to a picture editor's desk first – a great plus in newspapers.

In the middle of a quiet afternoon a reporter picks up a story on his calls, about a mother and her two children who have been killed in a fire at their home in Redhill, and the agency swings into action. Photographer Jonathan Bainbridge is called on his car phone and diverted straight there, while a reporter leaves for the scene instantly. As they get there, Jonathan starts taking pictures both in black and white and colour, and the reporter talks to the neighbours, collecting a family picture. A difficult task, coming as it does minutes after the tragedy.

Opposite King Hussein of Jordan's son, Prince Abdullah, taking a break on his officer cadet course at Sandhurst.
ROGER ALLEN

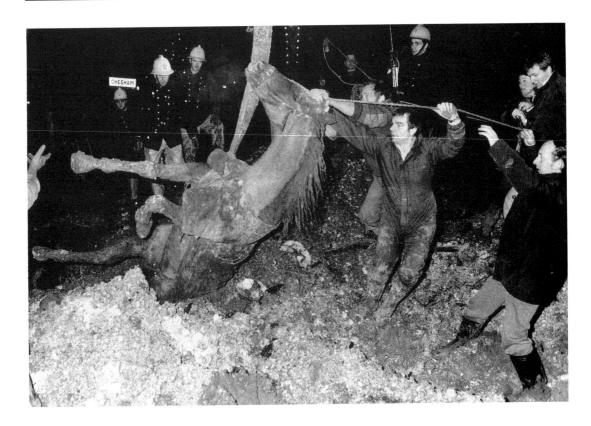

This horse had been grazing in a field near Chesham in Buckinghamshire when it suddenly disappeared down a hole in the ground which opened up beneath it. Firemen struggled for two hours to free it.
JONATHAN BAINBRIDGE

As Jonathan speeds back to the office, a team of reporters is on the phone, constantly updating the story from the police, fire and ambulances. A brief scene-setting story is written and automatically filed to all the papers. The calls from newspapers begin and both Denis and Don are busy alerting news desks on papers, radio and television stations to the story.

Jonathan reaches the office, processes quickly, and copies the 'collect' he has arranged to borrow. He turns the colour around in forty-five minutes and a bike stands by to roar off to the BBC and Thames Television news rooms with the slides for the early news bulletins. The papers jostle in the queue for the wire machine and the pictures are sent in turn to them all. An hour and a half later, every national has the pictures. The story is being constantly updated and the late reporter will continue to make checks into the night. Persistent enquiries

confirm later that the fire was the result of arson, and a few days later murder charges will follow. The agency settles down. Jonathan and Denis walk the nineteen steps to 'The Stag' – the pub next door – and sink a pint.

Exciting, yes – tomorrow could be just another day, or it could be even more hectic. That is one of the joys of the press world.

Just as Denis climbs in the car he's called back by the late reporter who points out the possibility of a good story in Devon the next day. Unlike most agencies, Southern will go anywhere for a good story, so with a wink Denis asks Jonathan: 'Any chance of being on Dartmoor for nine o'clock in the morning?' Jonathan shrugs philosophically. 'Who for?' he says, as he remembers he's a member of the agency team that never turns anyone down.

This baby owl flew into the side of a police dog van in the middle of the night and was offered the shelter of the cells at Dorking in Surrey until it had recovered.
ROGER ALLEN

Day to Day in Fleet Street

All around the world news happens, twenty-four hours a day, seven days a week. It can be tragic or happy, but once it becomes so important that it interests those outside the country where it originated then the international agencies move into action.

Peter Kemp of Associated Press

A weekly paper may have a circulation area (in which it reports the news and sells papers) about the size of a large town; an evening paper will cover a large city, and the national papers deal with the whole country. The international agencies know no boundaries. If something happens anywhere in the world, then they make all efforts to report it and deliver pictures to their subscribers around the globe. The two dominant agencies are Reuters and Associated Press. The former was founded by Julius Reuter, who used carrier pigeons to take the stock exchange prices to his earliest clients. His business boomed, and Reuters is now an international corporation, not only reporting news but supplying financial and economic statistics to business people the world over. Its rival is the Associated Press, an American firm with world-wide cover. Their news headquarters are in New York, above the ice rink in Rockefeller Plaza at the top end of Fifth Avenue. The building never sleeps, because of time differences. Its circuits hum twenty-four hours a day with political, economic and spot news stories.

The Associated Press has offices in all of the capitals of the world, each linked by private dedicated telephones and telex circuits and by satellite link-ups. Each office has a bureau chief in charge of news cover and in some, depending on the size of the country, there will be a staff of photographers. In some of

the smaller outfits there may be just one photographer, with a portable wire machine waiting to go.

The European headquarters are in London and control the output of the European, Middle Eastern and African staffs. I worked there as a Desk Editor for a while, and soon came to realise how small the world is. Using a computer network, messages and stories can be quickly routed to any corner of the globe, and it was possible to watch a story build in any country simply by keeping an eye on your screen.

All of the bureaux are linked together and in each country the newspapers are all connected to a national circuit. So when a picture is transmitted from any point on that network, it will be picked up in each capital and distributed all around each country simultaneously.

With the whole world to cover, many 'stringers', or locally-based photographers, are employed. They are often part-time, and when a story breaks the local stringer will notify his bureau chief who will in turn alert the whole network in minutes. The European network is also connected to New York in the West and Hong Kong in the Far East, and a picture on a wire machine in Frankfurt can be received anywhere in the world just as fast as the machine can transmit it.

It takes a special kind of photographer to work for an international agency. He has to be totally self-sufficient and resourceful. He has to be fully conversant with all darkroom techniques, and must be able to master the electronic side of picture transmission, sometimes with very primitive equipment.

Peter Kemp, one of the London-based AP photographers, is the model of how an agency man should be. When he was at school in Middlesex, he was a keen cricketer and interested in all sports. He was particularly keen on current affairs and history, both of which have stood him in good stead in his later career. He joined the *Bucks Advertiser* at Uxbridge as a general dogsbody, and was soon taken with the idea of photography. He would tag along with the photographers as they covered the area, and soon became reasonably competent, finding that he had a flair for it. He was shortly appointed a weekly photographer and consolidated his new-found talent.

At that time there were three London evening papers – the

Peter Kemp of the Associated Press.

Standard, the *News*, and the *Star* – and they all were crying out for pictures from the different parts of the London area. Peter soon started supplying them with pictures, not of hot news stories, but little human interest and animal pictures that were delivered one day and used the next, and known as 'overnights' because they were not taken on the day of publication. He soon made some contacts in Fleet Street, including the AP desk. Because he lived at Harefield, near the airport, he was sometimes asked to cover some of the arrivals and departures for them, and soon the odd weekend assignment followed. He was asked in 1966 if he would like to join AP full-time as a freelance. He was loath to leave the rather pleasant life he had in Harefield and also realised that he would have to play less cricket, but Fleet Street called and Kemp answered.

This picture of a riot in Belfast in 1972 shows rioters trying to lever the turret off a Saracen armoured car. Shot on a 50mm lens, which Peter Kemp feels gives some of the best and most true perspective pictures possible.
PETER KEMP

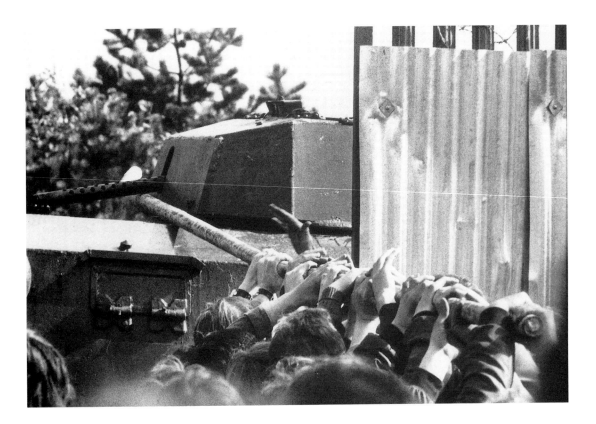

In 1966 he covered much of the training and many of the build-up matches for the World Cup being held in England, and spent a lot of time on special orders from AP subscribers for various national teams in action.

In 1968 he was sent to Northern Ireland to cover the start of the Civil Rights movement, and he soon became proficient with both portable darkrooms and wire machines. He also started to build up his knowledge of the Irish situation which has always helped him on the streets. On my first trip to Northern Ireland, Peter 'held my hand' for me, and introduced me gently to some of the basic rules of safety in public order situations. He was there in August 1969 when the first stones were thrown in Londonderry at the Apprentice Boys' March, and, with a few exceptions, has been back for every major event since. At times he was spending more time in Belfast than in London, and quickly established himself as the man for that particular corner.

In 1969 he was taken on to the staff, a step not altogether forward.

'I liked being a freelance,' he said. 'It kept you on your toes. If you didn't have a good idea you didn't earn any money, but being on the staff did mean greater security.'

In July of that year he covered his first major overseas assignment, the visit of US President Nixon to India. This introduced him to a country which he grew to love, and to which he was to return time after time. In December 1970 he was sent to cover his first war on the Indo–Pakistan border. He was the last photographer to get in before the Indians closed all the borders and set off from Delhi to the North-West Frontier by taxi – not, I would add, with the meter running, but hired by the bureau for the duration. His driver worked for the Indian Tourist Board, so Kemp got a guided tour to the front line.

Here he got a good break. He persuaded the driver to stray from the main road and they ended up in the middle of a column of Indian armour. Surrounded by Centurion and M24 tanks, the taxi was soon spotted and once Kemp had persuaded an officer he was not a spy he was escorted away – just as he was leaving two helicopters rattled in with young wounded Indian soldiers. The officer was so upset by the

plight of his countrymen that he forgot about Kemp, and left him to take pictures. Peter sent them back to Delhi in the taxi, and as they were the first seen from near the front line, he scored heavily with publications. It was also his first sight of badly-wounded people and dead bodies, and, although he thought little of it while he was busy taking pictures, he was struck some hours later by the gravity of what he had seen. This effect is common in combat photographers; they are usually too busy concentrating on their own safety and getting good pictures, and the full impact only hits later in the relative quiet of a hotel room or billet.

Later that week he had a second stroke of luck. He saw streams of people coming away from a village hit by bombs, and as he approached the village he saw an old lady sitting upright in a brass bedstead wailing as her house had been blown away. The film was sent to Delhi, this time in an army helicopter, and again appeared on the world's front pages.

He was back in Delhi on the day a cease-fire was announced, and sped round to catch Mrs Gandhi in her garden celebrating with visitors.

Myron Belkind, the Delhi Bureau Chief, decided that Peter should now try to cover the Pakistan side of the border, following Bhutto's takeover. Because it was not possible to go directly from India to Pakistan, he was sent first to Tehran, then to Kabul, and then into Pakistan.

So Christmas Eve 1970 found him in Kabul in Afghanistan with a portable darkroom and wire machine trying to persuade people he was a tourist heading for Pakistan. The airport was shut for three days and time was precious. Out of the shadows in a bar came the owner of one of the only two Toyota cars in Afghanistan. Being a bit of a wheeler-dealer, he agreed to take Peter to the border. Needing a bit more money and some guidance, Peter set off for the British Embassy.

The imposing mansion-style building behind high walls was shut up, with a sign saying 'come back after January'. Freezing cold and frustrated, Peter climbed the gate and sang 'Rule Britannia' as loud as he could, until an old boy in a threadbare greatcoat shuffled out. Grateful for the advice he received, he then negotiated a price for the run to the border. He had £20 on him, offered £15, and when it was accepted,

(DEL=1)DELHI.INDIA.Dec.29(AP)With his late mothers portrait staring down at him,the Indian Prime Minister Rajiv Gandhi,waves triumphantly to his supporters at a rally in Delhi today,as it had become known that he had swept to power in the Indian General Election(Associated Press wirephoto.Peter Kemp.stf. 333 1084pk)

climbed aboard for the journey through the Khyber Pass and on to Rawalpindi.

It was a clear sunny day – clear enough to see the long rifles of the bandits in the hills – as they sped towards the Pass. It closed at 4.00 p.m. each day, and the thought of being left at the mercy of the bandits spurred them on to get there in time. The taxi was paid off and Peter got the stamp in his passport, which still fills him with pride – 'The Khyber Pass'! The border guard gave him an orange for Christmas and he boarded the bus for Rawalpindi.

The windows were blacked out with mud and he sat in the centre for safety. About seventy people got inside and a further dozen clung to the roof. Kemp found himself next to a goat, which fortunately behaved impeccably for the entire journey. The trip was 110 miles, cost approximately twenty-five pence, and, says Peter, was one of the finest he has made in his life. At each stop the bus was beseiged by locals selling sweet tea and delicious home-made biscuits.

When he left the bus in Rawalpindi, the passengers cheered and he swears he saw the goat smile!

He has been back to India seven times and has formed a wonderful love-hate relationship with the country. He loves the place, but hates the bureaucracy which holds back the farming which, he feels, properly managed could turn the country into the bread basket of Asia. It has, he says, a well-educated young population held in check by an ageing and vast machine that is cumbersome and inefficient.

The main problem for the photographer in a strange country is to move the picture quickly once he's got it. In bigger countries, it's sometimes easier, but it's also more difficult in some. In 1978, Peter was in Oman with a Royal Tour. No one was planning to wire pictures from Oman as the telephone system was known to be bad. At a reception for the touring press he met the Minister of Information who asked how he was. 'Impotent', replied Peter, explaining the frustration of not being able to wire from Oman. The Minister called over the Head of the Omani television service, and ten minutes later they were in the basement of the television station looking at a frame with two hundred sets of telephone connections. Kemp patiently tried each set with a portable

phone for an hour until he found the right ones. Tying an olive leaf to them with a piece of cotton, he returned next day with a marvellous picture of the Queen losing her hat. He called London, introducing himself as 'Olive Leaf Oman', and filed his pictures on to the front pages.

He has worked in stranger places. On a Royal Tour in Jordan, he blocked off the entrance to a 2,000-year-old cave with black plastic to make a cosy nook for a darkroom. He thinks it may be the oldest darkroom in existence, but is happy to be proved wrong.

It's a far cry from modern technology at an Olympic Games, where forty different sports will be taking place at once, and AP will fly in a complete bureau with editors, photographers and darkroom technicians to handle the five hundred or so

The Russian coxless fours show exhaustion after winning the gold medal in the World Rowing Championships.
PETER KEMP

films a day. Each country's papers will need special pictures of their competitors (if they are winners or not), putting a heavy demand on the AP service. With papers in different time zones the processing never stops, each picture being captioned in English, the universal language of AP, before it is transmitted. These days, AP photographers shoot entirely on negative colour stock – a black and white print can be made from the negative, as well as colour separations for subscribers who need news in colour.

Peter Kemp has recently returned from the conflict in the Gulf, and the clarity of light there, while making exposures easy, is no friend to colour. White ships reflecting the sea and sky are difficult to filter. When the Bridgestone was hit by rockets, Peter sent material direct to New York, who complained that the colour was way off balance. Peter had a difficult job explaining to them that the white superstructure was reflecting the red lead paint of the deck below. He also had difficulty balancing the sky on some shots, trying for a while to correct the yellow cast that wouldn't shift. It was only when he went outside in frustration for a smoke, that he noticed that a sandstorm had turned the sky yellow.

He has covered what he calls three 'proper' wars – the Indo–Pakistan war, the Yom Kippur war, and the Turkish invasion of Cyprus. They were, he says, a mixture of shooting wars and propaganda wars. In war, photographers should be subject to a measure of control, says Kemp. They cannot be allowed to wander around the scene of battle indiscriminately, for one simple reason – if they pop their heads and camera up without warning, they are liable to be shot. Even more important, they may draw incoming fire, and soldiers around them may be killed for no good reason.

Also, they do need a measure of guidance. At an early briefing it may be decided to visit point A and the cameras will set off accordingly. Later that morning point A may be taken by enemy forces, and unless journalists are made aware of this, they could find themselves in a serious situation. 'Remember,' says Peter, 'that people wandering around a battlefield not in uniform and carrying cameras are likely to be seen as spies; in some places you can get shot for that.'

The shooting war is easy to see – tanks, armour and men

lobbing explosives at each other in various amounts. Hills and ridges can be identified, objectives taken and bridges blown up. The propaganda war is a little more subtle.

Peter was once on the Golan Heights during the eternal Middle Eastern conflict. He and a Danish television crew were sharing a jeep and had got as far forward as they could; they hadn't realised that they had, in fact, crossed the Syrian lines. They were stuck in a pothole, trying to reverse, when they noticed soldiers looking at them who were very different from the Israelis they had just left. They got out of the jeep gingerly, and looked about them. Much to their relief the Syrians pulled back, and they started taking pictures of five crippled tanks just over the ridge; under one they discovered a Syrian, badly wounded and unable to speak, but clearly asking for water. They took a couple of pictures and immediately sent the reporter back to the Israeli Liaison Officer they had left behind to get help.

The Israeli team arrived, and with infinite care and patience they extracted the Syrian from the mangled tank. He had been badly burned by an armour-piercing shell, and his skin had the texture of lino. Armour-piercing shells work by releasing a charge of phosphorus after they have struck their target, and this literally burns its way through the metal. The unfortunate soldier had taken a large dose on his body.

Kemp and the television crew returned to base, and, as in all wars, he submitted his pictures for censorship before release. There was a categoric refusal by the Israelis to clear the pictures, arguing that, if they were seen in Syria, reprisals would be inflicted on Israeli prisoners of war.

Two days later an exchange of prisoners took place and after pleading from Peter the pictures were released. Although the pictures appeared in Jewish and Arab publications, they were held up as a humanitarian gesture by the Israelis. The Arab press, however, chose to say that the soldier in his singlet being helped by the Israelis was a Syrian farmer who had been the victim of an Israeli napalm attack.

'All you can do in a war,' says Peter, 'as a journalist, is try to be honest. Take it like you see it, and don't distort things if you can help.'

He is somewhat gloomy about the future of police–press

relations – he feels that they are going the same way as in other countries with a tougher regime.

'In the old days you could turn up at the scene of a fire and ask the sergeant in charge if you could go round the front to take a picture. As often as not, he would go for a one-minute walk while you nipped around the front and got your shot, without any inconvenience or danger to anyone. Not so any more. The rise of urban terrorism has made the exclusion of cameramen the norm rather than the exception. The Metropolitan Police, in particular, make life very difficult if they can. The public demand honest pictures and the British in particular believe what they see in their papers – we cannot let them down.'

Peter Kemp's greatest successes have been with pictures of varying events. He got hundreds of front pages all across the United States with the wedding of the Duke and Duchess of York. And he covered the bomb at the House of Commons well, when his picture, showing the instantly recognisable outline of Big Ben, was published around the world.

The international agencies keep track of their results in papers around the world using a system called a 'play report'. Each day the publications of their own pictures will be counted up along with those of the rivals and a football score will emerge. Thus, in Belgium it would be possible to say that AP beat Reuters by 3–1 on a particular day, and agency chiefs can easily keep track of how their material is going. The first question on the phone from a photographer anywhere in the world is always 'what's the play?' Depending on the score, a drink is taken either in celebration or commiseration.

The main target of the agencies is to be first on the wire, and often picture quality can be sacrificed for this. Also, with the number of stringers they employ, standards will vary enormously. Generally though, they provide an excellent first strike at a running news story. Sometimes they lose sight of the object of the exercise – the production of good pictures – and get too bound up in the electronics and technology in the constant race to move more quickly and beat their rivals.

The last word must be with Peter Kemp.

'You can have the best picture in the world, and you want to

show it to the world before anyone else. The main question I face is, how the hell to move it quickly enough. The quicker the movement, the better the play and that's what I get paid to do.'

Mike Maloney of the *Daily Mirror*

Fleet Street seems to divide itself up quite naturally into two halves – the tabloids and broadsheet papers – or, as Kelvin McKenzie the Editor of the *Sun* says, 'popular and unpopular papers'. The public perception of the tabloids is perhaps closer to the more traditional image of the press photographer, living largely in the world of soap operas and showbiz, with a side-salad of crime and sex. Many of the so-called 'downmarket' tabloids are indeed very much in this line, but such papers as the *Daily Express* and the *Daily Mail* like to think that they have risen slightly above this. It's interesting, however, to compare their treatment of long-running sexy court cases, which they all report with lurid headlines full of eye-catching phrases. A paper like the *Daily Telegraph* has far more detail of the nuts and bolts of the offence for anyone with the time to plough through it.

Tabloid newspapers should not, however, be seen as inferior products to the broadsheets – they are simply aimed at a different market. They are also produced with as much care and attention to detail as any of the qualities. In this way the newspaper world is rather like the catering profession. We are all of us in the business of supplying the readers with news that they can easily digest. Some of us are working for the grill room of The Savoy, while others are preparing McDonald's hamburgers. There is no difference in the high standards that both demand for their different markets. Although McDonald's are 'only' making hamburgers, they are producing the best ones in the world, and satisfying millions of customers in the process (many of whom would neither feel happy nor comfortable in The Savoy where the food and presentation may be too rich for their taste). It is impossible to say which of them is doing their job most

efficiently – they both please the market they set out to attract, and both succeed supremely well. It is the same with newspapers – the tabloids produce what their readers want in large quantities, and the broadsheets approach news in a different style for *their* readers. It should never be though that the tabloids are thrown together; far from it, their market is accurately researched and the news and pictures are presented in exactly the form that the readers like. That's why they sell millions of copies a day.

It must be easy for a tabloid photographer to become cynical about his work, dealing as much of it does, with events of little real significance. They are working in that strange world where the edge between fact and reality blurs, when Anita Dobson really becomes Angie, and soap opera fans believe every word they read of their idols. Also, it must be easy to slip into photographic cliché when once again they are faced with the task of injecting some life into yet another photocall for a new television series.

One man who regularly manages to come up with the goods when something that little bit different is needed is Mike Maloney of the *Daily Mirror*. If you were to ring up Central Casting in Hollywood for a tabloid photographer accurately drawn from life, they would model their choice on him.

He started in Lincolnshire, when at the age of ten he was bought a box brownie and took pictures of Whittam Park near his home. His mother paid to have the film developed and when they came back from Boots the young Maloney fell on them. His were easy to spot – all the ones his father had taken had cut the heads off the subjects. Mike thought he would try again. He continued his interest in pictures while he was at school and when the time came to leave he joined a firm of industrial chemists where his job was to suck acid up into a pipette and measure the strength of it. One day he sucked a bit hard and ended up with a mouthful of nitric acid burning the taste buds off his tongue; for three weeks he couldn't taste a thing, not even that Lincoln delicacy plum bread which he had become fond of.

Thinking that chemistry was perhaps a bit dangerous he got a job as a tea boy at the *Lincolnshire Chronicle*, the local weekly paper. He worked initially in the press room helping to

Mike Maloney of the *Daily Mirror*.

print the paper and would take pictures in his spare time. He submitted his shots of ducks on Brayford Pond to the Editor each week, and if they did not make the paper he took constructive advice from him. He wasn't allowed in the darkroom but he would tag along with the photographers whenever he could, and picked up many tips from them. Eventually he got the odd assignment from the Editor, and on some weeks he was getting more pictures in the paper than some of the staff, much to his embarrassment. He studied the photographic magazines avidly, poring for hours over the adverts for shiny cameras, and lapped up every word he could read on Fleet Street.

He started getting the occasional assignment from other people and sometimes did a job for one of the nationals. He desperately wanted to become a full-time photographer, but a vacancy never came up in Lincoln, and so he made the big decision to come to London to freelance and try his luck.

He left home, used some of his savings to buy a couple of second-hand cameras and rented a flat in New Barnet. He started off by working for London News Service, or, as it was known then, Fleet Street News Agency. This agency has produced more staff for Fleet Street than any other training organisation in the world. In return for a basic wage and a lot of hard work, young hopefuls can learn more in three months than in a three-year course of theory. Each day they will try to beat the rest of Fleet Street at its own game and each day will go into the offices and meet the editors. It is the finest way into the business, and every newspaper has a core of staff who have at some time worked from the Agency's office in Exmouth Market, above a shop and a busy street market and some ten minutes from Fleet Street itself.

Maloney worked all the hours he could and soon found that he enjoyed the life. He would start first thing in the morning working for one of the three evening papers and end up late at night looking for something for the next day. Being young and single this life suited him and he improved steadily in his ability. His housekeeping, however, didn't keep pace with his photographic duties and when (after a long time) he took his first weekend off and invited a girlfriend from Lincoln down to show her the bright lights of London, she took one look at the

washing-up left in the sink at his flat, glanced round the rest of the *bijou* residence, and caught the next train back to Lincoln. Maloney, of course, went into the agency and carried on as normal for the weekend.

One advantage of the agency system was that his face became known to all of the picture editors very quickly and he soon began to make a name for himself in the showbiz world. He liked the glamour and glitter of it all and certainly enjoyed popping in and out of the grand hotels in London. He got on well with showbiz people and he seemed to have found his corner. It was all a long way from Lincoln.

After eleven months with the agency he took another big step and decided to freelance for himself. He got promises of work from Alan Reed, the Picture Editor of the *Evening News*, Gerry Cook, then Picture Editor of the *Standard*, Alex Winberg of the *Daily Mirror*, and Andrew Harvey of the *Daily*

That's showbiz! Les Dawson pulls a face for a miracle baby.
MIKE MALONEY

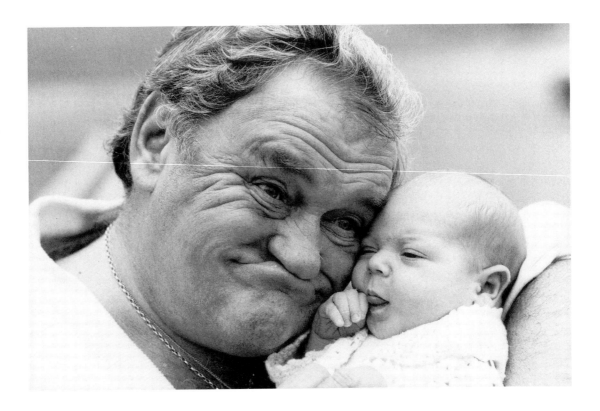

Left High society I. Shock, horrors! Naked ladies pass the Leander Club, Henley Regatta, 1987.
MIKE MALONEY

Below High society II. Face in the crowd. The Princess of Wales at Ascot, 1987.
MIKE MALONEY

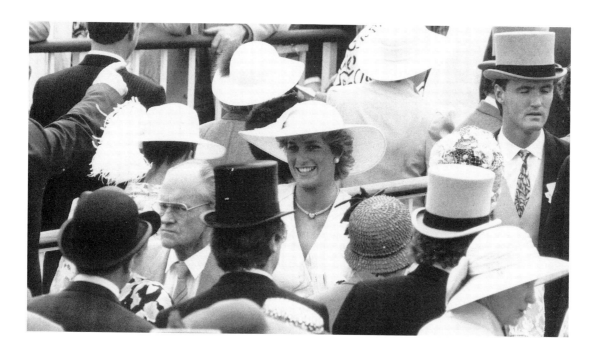

Express. He put in his notice and waited for his first call. It came at 10.00 p.m. from Michael Ives (who was looking after the night desk of the *Evening News* at the time) asking Maloney to cover Noel Coward's birthday party celebrations at The Savoy. So the 22-year-old from the country set off on his first Fleet Street job for himself.

Although he had become used to the high life a little, he couldn't believe what he saw when he arrived at the party. The guest list read like a *Who's Who* of the theatre, and after taking roll after roll of pictures Mike was given his first glass of champagne and tasted caviar for the first time – not bad, he thought, for a lad from the country. The evening ended with him dancing with actress Rachel Roberts. At 2.30 in the morning a slightly tipsy Maloney walked back to his Capri parked on the Embankment, sat on the wall, looked at the lights twinkling in the Thames, burst out laughing and shouted, 'I'm actually being paid to do this!'

This was, he decided, definitely the life for him, and he launched into Fleet Street in a big way. He worked what is known in the business as 'doublers', starting at the *Evening News* at 7.30 in the morning, working through until late afternoon, grabbing a quick bite, then setting off on another shift for the *Daily Mirror* until 1.30 in the morning. He kept up this punishing routine for over two years, and, while the going was tough, the rewards were good. He had hundreds of publications and managed to save a considerable sum of money and buy himself a small house in North London. He has always been good with money – his property investments have borne fruit, and he now lives in some style in St Albans.

He worked all the hours he could and covered some of the major news stories of the 1970s.

One day he got the best picture of the footballer George Best, sitting in despair in the back of a police van following his arrest on drugs charges – he caught the image through a van door in a split second. At the height of the IRA bombing campaign in London, the *Evening News* had a tip that a bomb had been placed inside a large Oxford Street store. The police were instantly told and Maloney was despatched to the scene. He arrived just as the shoppers were being evacuated; grabbing a couple of shots, he went inside the store in the

confusion and hid behind a rack of ladies' clothes and waited. The store became quiet and out of the shadows came a man dressed all in grey who advanced gingerly towards the device which had been placed on top of a sand bucket. Maloney held his breath as the man reached forward and defused the device; he took pictures with a 200mm lens and waited patiently until the store reopened. He sped back to the office and his amazing picture was splashed over the whole of the front page. He was summoned into the Editor's office to shake hands with Don Boddie, who gave him a glass of the champagne that he was developing such a taste for.

His next meeting with the Editor was to be in slightly different circumstances.

He had been assigned to cover the Pied Piper Ball, the social event of the year. He was able to get in because Associated Newspapers, the owners of the *Evening News*, were sponsoring the event for charity, and this was to give him exclusive access to the party.

Dressed in the dinner jacket he now felt was an essential part of his wardrobe, Mike mingled with the guests, taking lots of pictures, but still looking for that special one for the front page. He wandered around and saw the figure of reclusive billionaire Paul Getty dancing with Margaret, Duchess of Argyll, and he knew that this was the shot he needed. Fitting his Metz flash to the side of his Rolleiflex as the couple turned to face him, he let fly. Just as when you hit the perfect shot in golf, he knew he didn't need to take another frame. He could see the dour face of Getty and the Duchess perfectly framed in the viewfinder of the camera.

As Getty had not been seen in public for some years, Mike knew the value of the shot. He phoned the Picture Editor of the *Evening News*, Alan Reed, at home, getting him out of bed at 1.30 in the morning. Reed also realised the worth of the picture, and said that he would come straight in to Fleet Street and meet Mike in the darkroom to see the picture. Both men waited with bated breath as the image appeared on the film; the hypo cleared and looking straight at them in perfect focus was the elusive Getty. They made a 20×16 print and both went home to bed to sleep soundly, knowing they had a great front page in the bag. After a lie-in, Maloney

Opposite Michael Jackson in
concert, Tokyo 1987, at the start
of his world tour.
MIKE MALONEY

arrived at the office at 8.00 a.m. and could hardly eat his
breakfast in the nearby 'greasy spoon', waiting to see the
picture that was going to crown his career thus far. He came
back and went straight to the machine room to see the very
first copies roll off the press.

He couldn't believe his eyes when, not only was the picture
not on the front page, but it wasn't even in the paper at all.
Almost in tears he went upstairs to see Alan Reed, who
immediately took him into the Editor's office. Bidding him sit
down, Boddie sent his secretary out for some coffee and
congratulated Mike on taking the finest news picture he had
seen for years. Mike politely asked why it hadn't been used if
it was that good.

The Editor explained that as soon as the dance had finished,
Getty had telephoned Vere Harmsworth, the owner of the
News, at his home in Paris. He had pleaded that the picture
should not appear. Harmsworth had agreed and instructed
Boddie not to use it. Boddie reluctantly fell in with his
proprietor's wishes, and Maloney got a look at the reverse
side of the power of the press.

Mike was by now working seven days a week and five
nights regularly. He enjoyed it and frankly was making a very
good living. He continued to save and invest his money and to
keep pace with the property scene – by this time he was living
in Elstree, in the shadow of the film studios, where he was
spending more and more time in the world he loved. He was
offered a staff job on the *Daily Mirror* (a paper he felt very
happy working for) by Alex Winberg, the Picture Editor he
admired so much. Reluctantly, he turned it down – he was
making such a good living and felt he couldn't take the drop in
salary! The offer was repeated a few weeks later and Alex
explained that this was the last time he would make it.
Whoever took the job would be doing the work that Mike was
doing, so it would be up to him if he wished to carry on at the
paper. It was, says Mike, 'an offer that I couldn't refuse.' So
at twenty-four Maloney joined the staff of a paper enjoying its
heyday, with photographers travelling the world to bring back
pictures to delight their readers.

He was given a bagful of Nikons and set off on the trail that
has taken him twice around the world. His first big foreign trip

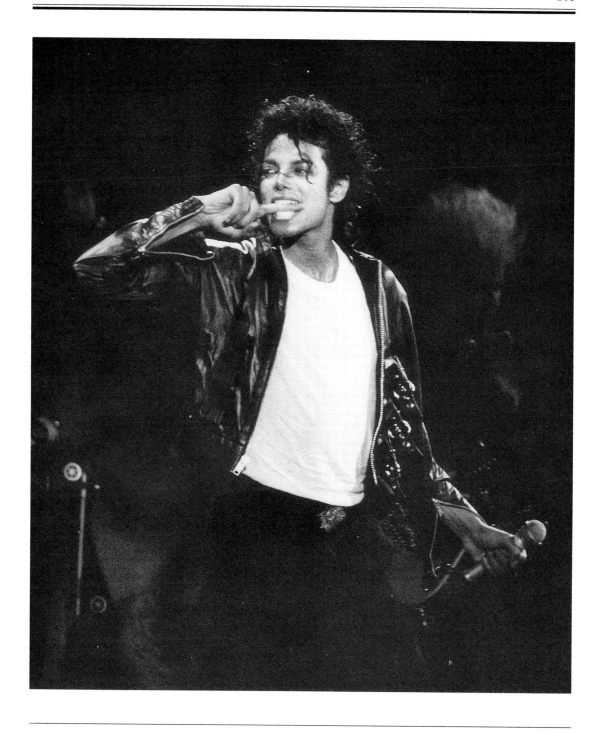

was to North Africa to take shots of the filming of Zefferelli's picture on the life of Christ. Three weeks in the sun and sand convinced him even more that he had done the right thing.

He joined Paul McCartney and his band Wings on an American tour and followed their every move, on planes and in limousines, as they crossed the country playing sell-out concerts. On the final night of the tour in New York, Paul invited him to dinner after the show in Madison Square Gardens, making it clear that he would be a personal guest. Maloney realised of course that he wouldn't be able to take his cameras; just as writers sometimes conduct interviews off the record, then also photographers sometimes have to respect someone's privacy and confidence by not taking pictures of them at every opportunity. 'Besides,' says Michael, 'why destroy years of friendship and confidence in a fraction of a second by taking a picture that makes your friend uncomfortable?'

Just before McCartney took the stage he told Mike, 'We've got a guest for you at dinner so don't be late!'

The concert was a smash and Mike made his way up to the eighth floor of Madison Square Gardens just as the screams were dying away. He sat next to Linda McCartney and when they stood up to receive their guest Mike was momentarily lost for words when he realised his blind date was Jackie Onassis! The rest of the dinner passed in a dream and the boy from Lincoln went to bed in Manhattan that night thinking that life was looking pretty good from where he was.

His love of sport has always stood him in good stead in Fleet Street and, although he loves the high life, he still enjoys a chance to sit on the touchline and watch the soccer action when he can. He's a good sports photographer too, having won an Ilford Award for a skating picture of Torvill and Dean in action.

Mike also possesses the quick thinking you sometimes need to pick up from mistakes. One day he was sent to the Connaught Hotel in London to take a picture of John Wayne, his boyhood hero, who was in London to make the film *Brannigan*. Due to a mix-up he arrived late, and the photocall arranged for 'The Duke' was over. Mike didn't give up all hope though, and retired to the bar to think of a way of

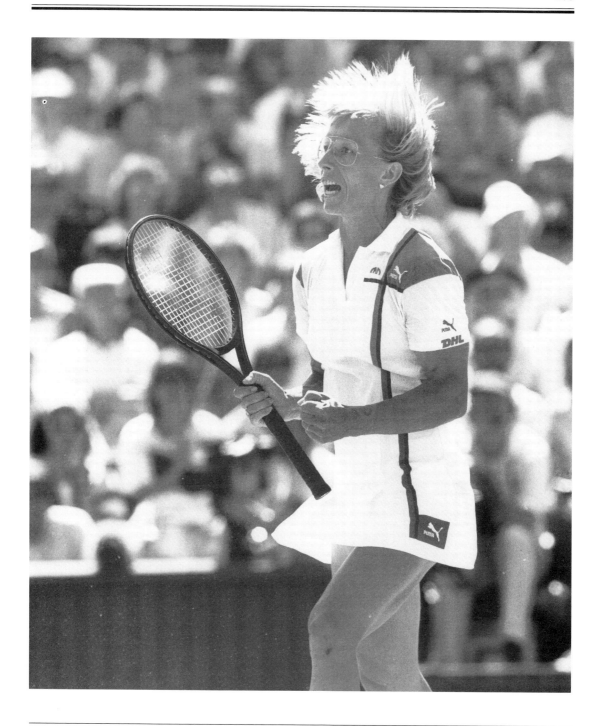

retrieving the situation. He got chatting to an American and Maloney bought him a beer. He explained that he had missed the picture and was feeling a bit down, and the man said that he was in John Wayne's party and that he may be able to help. Thinking that he was just being fed a line, Mike smiled and had another beer as the American went upstairs. Ten minutes later the man was back inviting Mike up to the great man's suite.

Mike walked through a set of double doors and waited for a moment. From behind the door came the unmistakeable gravel tones demanding 'Are you Mike?' Maloney stepped back and turned around and there was John Wayne towering over him, offering him a great paw of a hand to shake. They hit it off famously and after a picture session spent the rest of the afternoon playing poker. In the *Daily Mirror* the next day there was a great exclusive for Mike – a picture of Wayne holding up four aces in his hand, completely different from all the others that were published.

There is a serious side to the life though. One Sunday evening Mike was enjoying dinner at home when the office called and told him that two jumbo jets had collided in Tenerife, and that he was being sent to cover the world's worst air crash. Quickly changing, Mike left for Luton Airport where at midnight he and other Fleet Street photographers set off on the six-hour flight to the Canaries in an executive jet that had been specially chartered. The charter had been arranged at such short notice that Mike had to put something towards the cost of it – his share came to £7,000 on his American Express card before the plane even took off.

They reached the islands just as dawn was breaking and, because the runway was blocked in Tenerife, the plane landed at Las Palmas and they chartered a boat to reach the other island. After four hours at sea they landed, and for the next two days Mike and the others photographed the terrible scenes on the runway as the two planes smoked beneath the snow-capped volcano of Mount Teide that dominates the island. Their Madrid stringer had already found a wedding photographer on the island and they all worked in turns in the strange hot and cramped conditions, sharing an agency wire machine to transmit the pictures back to London.

Mike continued with world-wide assignments, and his investments were coming along nicely. He has two great passions in life – cars and steam trains. In 1981 he achieved one of his lifelong ambitions and bought himself a Rolls-Royce Silver Shadow – after owning a couple of Jaguars he felt that this was definitely a step up. To help him get around his jobs he even employed part-time drivers for a while, and one of these was Lovely, André Previn's daughter. Enjoying the image, he insisted that she should dress in a grey suit while he sat in the back. She didn't have a proper cap but Mike lent her his old St John's Ambulance Brigade one to top off her outfit. This story appeared in a gossip column, and as soon as the

Fashion and the £1,000 hat.
MIKE MALONEY

Rolls-Royce press office read about it, they sent a proper cap so that the picture would be complete. (Incidentally, he used to pay her £30 a night for this and he calculated that a taxi for the evening would have cost £50, so he consoled himself that it was cost-effective.)

Mike gets on well with Robert Maxwell, the owner of the *Mirror*, affectionately calling him 'RM'. When Maxwell arrived at the building to find his own Rolls Royce parked next to Maloney's in the underground car park at Holborn Circus he demanded to know whose it was. When he was told, Maxwell boomed out 'We must be paying him too much.' He then decided to put Maloney in his place noticing that Maloney's Silver Shadow was newer than his. Maxwell immediately bought a brand new one, something which Mike was not able to keep up with.

Mike has travelled extensively with Maxwell and gets on with his family well. He took the cover picture for Maxwell's biography, producing a superb technical result. He is at home in the studio and has a well-deserved reputation for technical expertise. He will use a large-format camera when it is needed and can handle lights and studio subjects well. He is also a Fellow of the Royal Photographic Society in recognition of this. In the past ten years he has won thirty-four major awards for photography, in classes ranging from news and sport to Royal subjects and portraiture. Since 1977 he has won a major award every year.

Mike enjoys Hollywood and usually finds himself there twice a year. He stays at the Beverly Wilshire in the same room near the pool and tries to lunch at the Beverly Hills Hotel or the Belair. As he says 'You may not be rich but you can live like a millionaire sometimes.' He thinks himself incredibly lucky that he enjoys a good life from photography which he still considers to be a hobby, and never dreamt in Lincoln that his camera would take him as far as it did.

He is a superb example of the tabloid photographer combining skill with that special knack of charming people around to his way of thinking, and, despite the somewhat lightweight content of his subjects, he will always produce a well thought-out and superbly executed print.

Tabloid photography is an art. It is just as difficult as the

Opposite This picture of Ronnie Corbett with the Duchess of York won Mike Maloney his thirty-fourth major photographic award – the Martini 'Royal Photo of the Year'.
MIKE MALONEY

Derek Jameson with a gathering of town criers on the Isle of Wight.
MIKE MALONEY

more thoughtful processes of broadsheet photography, and in some ways it is even more difficult. The ingredients are dreary and the photographer has to conjure up that picture with just a little more sparkle.

Where is the future of tabloids? Does it lie in colour? If *Today* is an example I think not. The Scottish *Daily Record*, the *Mirror*'s sister paper in Glasgow, has been using colour intelligently for years, but, as Mike Maloney says (and I agree completely with him), 'Colour will appear more and more in tabloids, but my first love will always be black and white'.

Getting the Image on to the Page

We've seen so far how the pictures are produced, how they are taken and how they are made available for the picture editors, now we shall follow their progress through the newspaper building. They actually follow two distinct routes: the traditional way, and *The Independent*'s style. The usual route into the paper is a complicated one. Reporters and photographers produce words and pictures that are sifted by several layers before publication.

The Traditional System

In a newspaper office there will be teams of sub-editors, usually arranged on a couple of long tables. These are called, with stunning logic, 'subs' tables'. At the head of the table will be a Chief Sub-Editor, and traditionally the most senior and experienced subs will sit nearest him, with the pecking order extending down the table to the new people at the end. These are called 'down table subs'.

Across the top of the table will be another desk, at which will sit the senior executives of the paper. These generally consist of the Editor and his Deputy and one or two Senior Assistant Editors. As the stories come in (now usually on computer screens) they are read by a 'copy taster' who sits at the end of this table (known in jargon as 'the back bench'). He or she will know the likes and dislikes of the Editor, and the political leaning of the paper. He will reject stories that do not fit in with the style of the paper, and draw particular attention to stories that he feels would interest the Editor of the day.

In the morning, usually at around 11.00 a.m., the Editor on a daily paper will chair a meeting of the senior executives of

the paper. This 'morning conference' will discuss the prospects for the coming day, and conduct a post-mortem on that day's paper. The rival papers will be compared, and any lapses in cover or presentation will be discussed. The executives will all come armed with a schedule of events they hope to cover, or in the case of features (longer articles that are not immediate news), an idea of what will be topical.

The News and Picture Editors will usually present their lists first, and the Editor will question points of detail, such as who will be covering what, which angles will be fresh, and what time the results will be ready. There will be a discussion, involving all the executives, about the general tone of the paper and whether there are any stories or pictures that need to be specially advertised. Arrangements will then be made to have bills printed for distribution to newsagents.

Mrs Thatcher, Norman Tebbit and Denis Thatcher in the early hours of the morning, celebrating the Conservative victory at the 1987 General Election.
JOHN VOOS

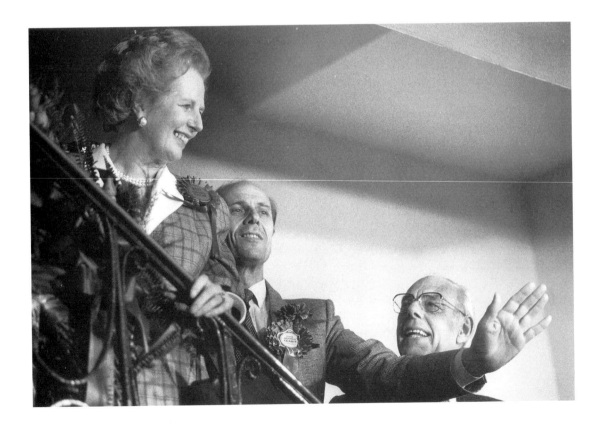

Sometimes two sections of the paper may wish to present similar articles or two sections may be in danger of repeating things, and the Editor has to decide which section could best present them. On tabloid papers these are 'full and frank' discussions as they say! Tabloid editors are not shy in pointing out an executive's shortcomings on a story, and the language can be quite colourful. I came out of a *Mail on Sunday* conference once, after a News Editor had received what may best be described as a 'free character reading', to be asked by him if I enjoyed blood sports! Corporate life in Fleet Street can be a fairly robust business.

I was Deputy Picture Editor at the *Mail on Sunday* at its launch and was working for Bernard Shrimsley, the Editor. After seven weeks the owners, Associated Newspapers, decided he was not the man for the job and to replace him. We

Front page news. The funeral of Eric Vardy, first of the Hungerford victims to be buried.
JEREMY NICHOLL

came in on a Tuesday morning (the first day of a Sunday-paper week, which runs from Tuesday to Saturday) to find that he had gone. We were told that the conference would go ahead as usual at 11.00 a.m. that morning. Being in charge of the Picture Desk that week I prepared a schedule, not knowing who would receive it. We trooped in to the Editor's office, and saw his upturned desk and papers scattered about the floor. The heating was off and the room was freezing.

'Don't worry,' a wit said, 'it'll soon warm up.'

At that point in walked Lord Rothermere, the proprietor. He announced that Associated's board had not been happy with the look of the paper and that the Editor had had to go. We were going to be taken over by the staff of the *Daily Mail* and they would be in charge.

The door opened to admit Sir David English, the *Mail*'s Editor, and his team, all identically dressed in dark suits, plain

In the news: just one result of the hurricane which struck Britain in October 1987.
BRIAN HARRIS

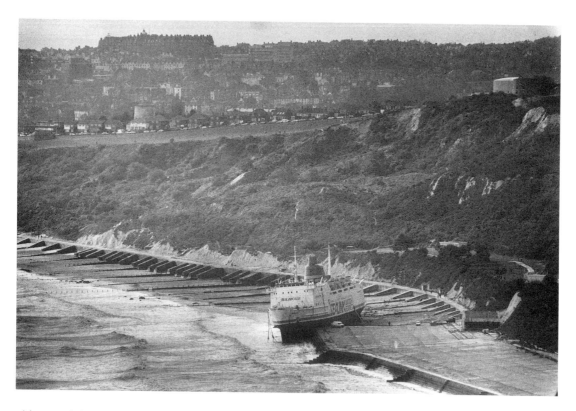

In the news: storm damage during the hurricane of October 1987 – a Sealink ferry aground on the south coast.
BRIAN HARRIS

shirts and dark ties. He explained that each department would be run by a *Mail* executive and that there was to be no mistake: 'The *Mail* is now in charge.'

During the rest of the day individual interviews were held with *Mail on Sunday* staff and many were replaced. It does have to be said though that the relaunched *Mail on Sunday* was a far better paper than the first attempt, and the sales figures have given it a commanding position in the Sunday-paper league. But back to the daily conference.

Afterwards, the Picture Editor will assign his photographers and they will cover the stories in the style they know the paper wants. They will, as we have seen earlier, either return to the office later themselves, or send back their unprocessed film. The films will be processed and contacted, and the Picture Editor will choose the best ones. These will be printed up by the darkroom and the strongest may be done

as a 15×12. Later in the afternoon the Picture Editor will produce a second list, this time of pictures he has actually produced. There will be a second conference at around 5.00 to 5.30 p.m., and once again all the executives will explain their lists. After the meeting the Picture Editor will hand over his pictures to the 'back bench'. After seeing the pictures and reading the stories they will decide which articles will appear on which page, and which pictures will appear with them. For the most part, they will have no formal training in photography, and will not possess much technical knowledge of it.

The Production Editor will make a rough sketch of the page, allowing for any adverts and leaving a space for the picture. It will have spaces, too, for the headlines. The rough plan will then be given to an Art Editor who will make a detailed

Opposite Reflected glory. Part of a news feature focusing on Britain's 'new rich'.
BRIAN HARRIS

Below Part of a news feature on the work of the Great Ormond Street Children's Hospital.
BRIAN HARRIS

drawing of the page, showing which style of typeface will be used for each headline, and giving an exact length to all the stories. After consulting the plan, the Chief Sub-Editor will give out the stories to the sub-editors for either cutting or expanding to the desired lengths. Headlines will be written, both to sum up the story and to fit the allotted space. This is an extremely skilful job, and a difficult one to master. The headline writer has to combine wit and originality, and is at the same time constrained to produce the exact number of characters and spaces needed to fill a line without 'busting', or going over. Incidentally, every story has a headline, even if it's only two words and quite small type. The main story on a page is called the 'page lead', and it is the large headline that tops this that is usually thought of as the headline.

The Art Editor will then take the chosen picture and fit it into the space left for it. Using a geometric scale, he will work

Lady Sayer on Dartmoor. This picture was taken for a news feature.
BRIAN HARRIS

out how much of the image will fit into the required space. He will turn the print over on a lightbox and mark up the image area on the back. It will then have a screen bromide made from it and will be pasted into the page. Pages will be made and bolted on to the presses and away they go.

Remember the Picture Editor? He was left behind at the stage when he handed his pictures for the day to the Back Bench. Remember the photographer? He went to the pub shortly after that. So you see it's a good system. It involves a caring photographer giving his film to an experienced Picture Editor, who then gives the prints to a set of people with no photographic training. The results as seen in the tabloid press speak for themselves. The same sort of system applies on some of the broadsheets with similar results.

The Independent System

At *The Independent* we have a different system. I'm not saying it's better, just different. We have the same system of conferences, so that we all know what we're doing. The Picture Desk will assign photographers who go out to take the pictures. On their return, they will process the film and print what they feel to be the best image – if they have time they will print it themselves. The Picture Desk will know first thing in the morning the amount of space available and the sizes of the adverts on each page. We won't cover many more stories than we reasonably need to fill the paper – this leaves us with a margin for errors of judgement. By mid-afternoon the Picture Desk will have decided what to offer for each page.

As we produce most of their pictures, the pages we influence the most are the Home News pages. The Picture Editor of the day (either myself or Michael Spillard my Deputy) will roughly assess the optimum size for the picture. We try not to crop them unless it actually improves the picture. The photographer will have cropped it in the viewfinder, then possibly on the enlarger baseboard, so we feel we should try not to hack at it further. If he or she is around the photographer will be asked which picture is felt to be the best. Sometimes an amicable discussion will ensue, and

Opposite above Home News: a word in your ear from Jim Swanton for Colin Cowdrey on the bidding at the MCC Bicentenary Auction at Lord's Cricket Ground. Tim Rice listens in.
KEITH DOBNEY

Opposite below Home news: newly-restored locomotives, 34105 *Swanage* and S15 Class No 506, go through their paces on the Watercress Line, Hampshire.
HERBIE KNOTT

Below Home news: modern artists Gilbert and George taking tea with Mrs Phyllis Till at their local café in the East End of London (taken to mark the opening of an exhibition of their work).
HERBIE KNOTT

eventually a mutual agreement will be reached. The picture will be taken across to the Home Desk, where Christopher McKane, the Deputy Home Editor, is in charge of production. The Home Editor, Jonathan Fenby, decides the general policy of the pages and has the ultimate say in what will appear, but Chris McKane actually designs the pages.

He starts by deciding with the Picture Desk which pictures will look best on which pages. He will not design a page without seeing the picture and he will usually be led by the Picture Desk. Occasionally another amicable discussion will follow, and again a mutual agreement will be reached.

The pages of *The Independent* are made up on a screen, and the block for the picture can be moved around the screen using an electronic 'mouse'. When the positioning is decided, the computer will give an exact size for the picture. Normally this is calculated by the Picture Desk as being most appropriate for the picture, and sometimes the depth of a picture will be decided by the size of an advertisement on a

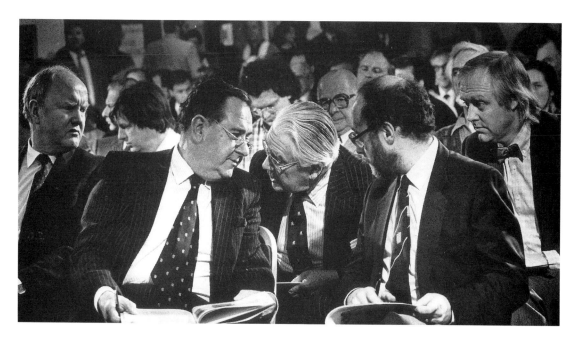

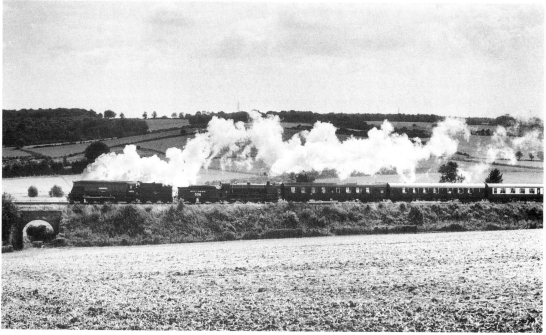

Atex screen make-up for Page 1 of *The Independent*.

The actual front page of *The Independent*

page. The pages with the smaller adverts are used for the best pictures, and some pictures are used on their own visual right with just one line of caption.

Chris McKane was on *The Times* as a Sub-Editor for thirteen years, finishing up as Chief Home Sub-Editor. He cannot understand the logic of making images fit pre-determined spaces. 'I don't cut words from stories just to fill set spaces, so why should I expect a picture to be cut to fit a space that is wrong for it?'

Chris is unusual in his approach to pictures. He has a genuine feel for them and his eyes light up, and he draws his breath in sharply, when he is shown a memorable image. Often when I have erred on the side of caution on a picture, he will suggest perhaps an extra centimetre bigger. He is the perfect production man to work with and although much praise (and many awards) have been directed at the picture editing of *The Independent*, he deserves full credit for the proper display of our pictures. Indeed, he will discuss the smallest details of layout with the individual photographer if the latter wishes to make a visual point.

After an agreement has been made on the choice, the print will be taken back to the Picture Desk for cropping, if this is needed, by a Picture Editor. Screen bromides will be made and checked by the desk before paste-up. If the bromide is too light or too heavy, then the production staff will happily re-shoot and try to improve it.

At 5.30 p.m. a front-page conference is chaired by the Editor, and stories with a choice of pictures, either home or foreign, are offered. We try to offer the best image of the day, regardless of subject. The whole conference will gather round to see the pictures and the front-page picture will often just emerge as the popular choice. Again, the page is designed around the picture – sometimes, if the picture needs to be bigger, a story will be moved 'inside' to make space for it.

The pages, complete with pictures, are transmitted via telephone lines to the printing plants at Bradford, Peterborough, Northampton and Portsmouth, and printing starts.

It is possible at *The Independent* for a photographer to conceive an idea, plan it with a picture editor, print it himself,

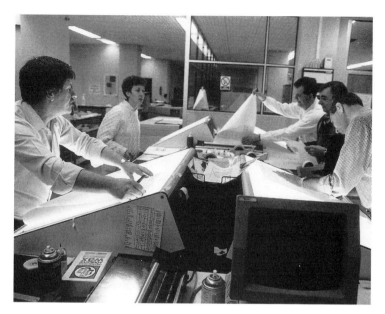

Left Page make-up at *The Independent*, for the first edition.
ALUN JOHN

Below Page make-up at *The Independent*, pasting picture bromides on to the page.
ALUN JOHN

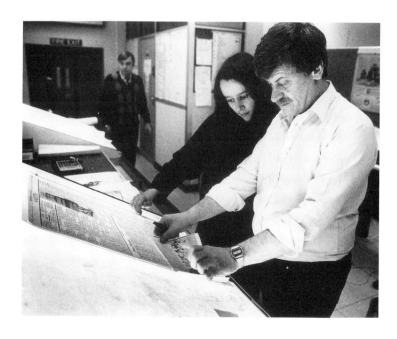

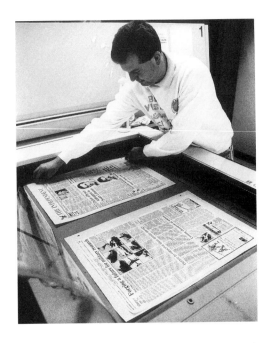

Above left Talking to the plants where *The Independent* is printed – at Peterborough, Northampton, Bradford and Portsmouth.
ALUN JOHN

Above right Complete pages of *The Independent* being fed into the DATRAX machine for transmission to the four printing centres. The process takes 45 seconds for the transmission of a pair of pages. Negatives are produced at the other end and after plates have been made up these are bolted on to the presses. The printing sites are linked by special telephone lines direct from the paper's headquarters in City Road.
ALUN JOHN

Opposite Remembrance Day. A war graveyard in Northern France.
BRIAN HARRIS

and then play a constructive part in the layout and presentation of the pictures. With involvement like this, it is scarcely surprising that our photographers are motivated to take such superb images.

The photographers are recognised at *The Independent* as making valuable and worthwhile contributions to the look of the paper, and sometimes, if it is felt that statements can be made better visually, then they will be the major part of the story. Our superb reproduction has also allowed them to attempt pictures which previously would not have been successfully reproduced in a newspaper, and this has brought new dimensions to daily journalistic photography.

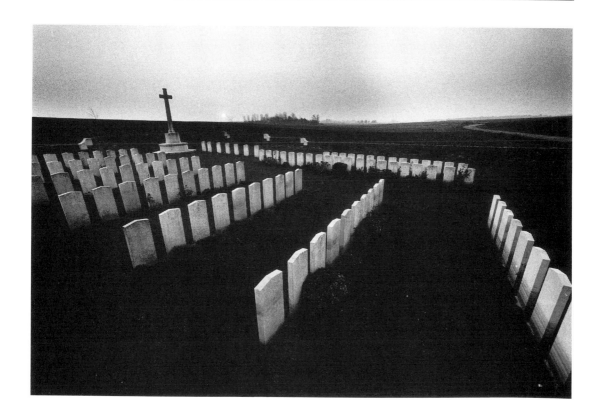

Sports Photography

A newspaper is much more than a sheet of news. It has features, City and financial news, comment, opinion and analysis, and a portion of entertainment.

Sport is actually quite difficult to categorise. In fact, if falls quite easily into any of the preceding descriptions, being both a form of entertainment enjoyed by many people, and occasionally stepping out of its stereotype. It can amuse, inform and entertain all sorts of readers from all walks of life. It can also produce some of the most visual images in the paper.

The London Marathon crosses Tower Bridge.
BRIAN HARRIS

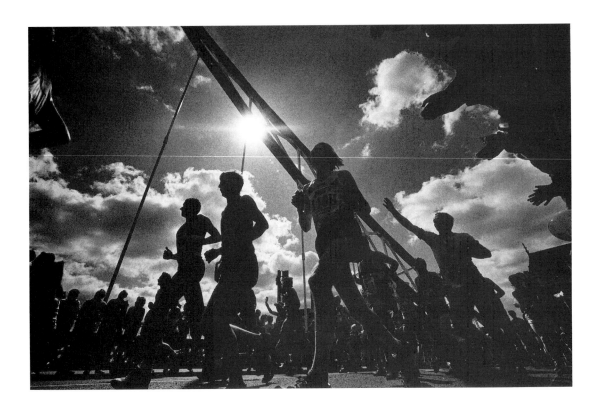

It takes a special photographer to tackle sport – he must be someone who has intelligence and intellect to follow the sometimes very subtle nuances of play, and above all someone with a genuine love for the game they are following. He must also have stamina – as we have seen earlier, newspaper photography is not a spectator sport, but a body contact game, and the successful photojournalist will be someone with a dedication strong enough to see them through hours of concentration, often in adverse conditions, and someone who is ever-ready for the split second that makes a good picture into a great one.

I must confess to having little interest in sport myself, except on the odd occasion when I watch my fellow Welshmen inflicting a defeat on the rugby field. I do, however, have a great interest in sports photography, and much admiration for sports photographers. The images they produce, often in a split second, convey the full range of human emotions – from elation in winning to despair in defeat. Also, by intelligent observation of a small incident, they manage to add a new dimension to the understanding of how sport functions. Television can bring us the instant replay and the close-up, but once again it will always be beaten by still photography in terms of permanence and a sense of involvement.

Becoming a Sports Photographer

At *The Independent* the stunning images produced by the sports photographers daily draw to the pages readers who wouldn't normally notice sport. They take a fresh look at subjects which have been seen a thousand times before and try to offer a new insight into the games. David Ashdown is the Chief Sports Photographer and is the model of what a sports photographer should be. In 1988 he won two Sports Photographer of the Year titles, one presented by Nikon Cameras and the other by the Sports Council, both I felt were particularly well deserved.

He started his interest in photography when he was at school in Wandsworth, South London, and although he played cricket for the school, he didn't have a great passion

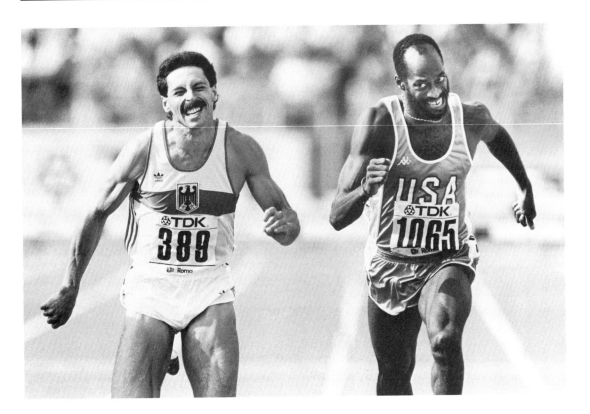

Above The World Athletic
Championships in Rome 1987. The
final of the 400m hurdles showing
Harold Schmidt and Ed Moses.
This was part of David Ashdown's
double award-winning portfolio of
ten pictures.
DAVID ASHDOWN

Opposite Part of David
Ashdown's double award-winning
portfolio.
DAVID ASHDOWN

for sport. He was more interested in motor cycles and steam
trains. He used to go off on his bike to see the steam engines
as they headed for the coast through nearby Clapham
Junction, and would take pictures of them, just for fun. In 1968
a friend who had already left school told him that he had a job
as a motor-cycle messenger with a photographic agency just
off Fleet Street, and that if David was lucky he could get work
there too. The main attraction was that the agency supplied a
free bike for the rider to use, and to David this seemed too
good an opportunity to miss. He attended an interview and
was taken on at the princely sum of £7 10s. a week.

David thought he was in heaven, being paid to roar around
the streets of London. He daily visited all the newspaper
offices to deliver the agency prints, and frequently went to
meet some of the agency photographers and then sped back
with their pictures. It was the speeding that he was

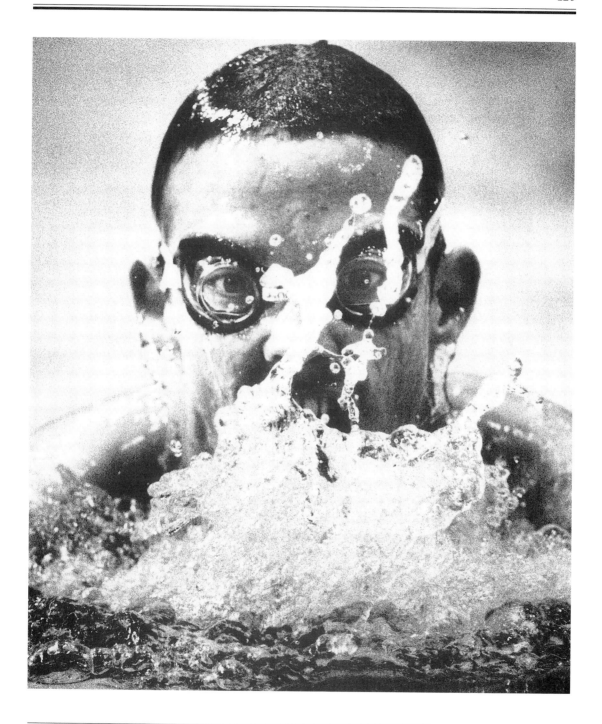

particularly good at, and after just six months' work with the agency he lost his licence and was relegated to being a foot messenger. This was not what David had in mind at all as he trudged the back alleys and maze of passages leading off Fleet Street and he soon thought of getting off his feet somehow. He became a glazing boy, peeling the prints off the glazing machines that constantly turned in the finishing room of the agency, and sorting the prints into piles ready to have the captions glued on to the back. He progressed well through the system, and became a developing boy, mixing chemicals and cleaning out the darkroom cubicles after the photographers had processed their films. He then moved to the position of printer in the main darkroom.

In Fleet Street a strange situation exists. Not all the photographers are proficient in darkroom printing – some have no interest in the technique, some just aren't able to master it, and, with the union position being that photographers take pictures and printers print them, there used to be little incentive to learn. Many of the people behind the names seen as bylines day after day would actually have a hard time printing the negatives they had produced. But times are changing and photographers are steadily being able to do what is after all a complete job.

David's time in the darkroom printing other people's pictures was, he felt, time well spent. 'It really brings home to you several very important points,' he says. 'It gives you an important feel for the job and teaches you to frame a picture properly without wasting too much of the negative area. It also teaches you the value of exposing the negative correctly, so that the prints can be done quickly and easily from correct density negs.'

While he was in the darkroom, David, like others before him, bought some second-hand gear and did the odd little job himself. Pop concerts were his speciality, The Rolling Stones and Jethro Tull being early subjects. He was still keen on motor cycling and now he had his licence back he would set off for motor-cycle racing meetings all over the South of England. He took one shot he was pleased with at Mallory Park and it was used on the front page of a motor cycle magazine, gaining him his first byline.

He used to get the agency to apply for passes on his behalf (most sports organisations won't grant passes to individuals, so amateurs find it difficult to gain access to the best vantage points). He used to supplement his income by taking pictures at weekends at events that the agency photographers weren't covering. He would use his key to the back door, come back on a Sunday afternoon and process and print his pictures, and then offer them to the papers for use on Monday mornings.

Eventually David was offered a job as a photographer with the agency and soon he was in the thick of news events as the man from Keystone. He covered the full range of news stories, from fires to fashion and Royal stories. He was at the siege of Balcombe Street in London when an IRA gunman held a family hostage for several days, and armed police ringed the square beneath the flat. I remember being there with him, and seeing his trade mark of the time, his bright red motor-cycle jacket, much in evidence on the police lines. He used his bike in preference to a car to get back through the London traffic, very often beating many of us back to our offices.

He covered football each Saturday and his love for sport began to grow with each visit to Wembley or West Ham. He would do most of the Royal jobs for Keystone and in 1977 he won an Ilford award for an excellent picture of the Queen at her Silver Jubilee celebration at St Paul's Cathedral.

In October 1978 the new *Daily Star* newspaper was launched and, leaving it until the very last minute, David approached David Bealing (then the Picture Editor) for a chance of some work. Although it was extremely late he was asked to work on the first weekend of publication and then offered the opportunity to do regular assignments. He left the agency and soon discovered that life on a paper was very different – especially the money! Working for the *Star* up to six days a week he was getting almost three times as much as he had been at the agency. Soon after he was offered a staff job and he eagerly accepted.

David covered many of the major stories of the time and still used to get around on his motor cycle, in his red jacket. Once he followed Jeremy Thorpe's car on his bike at the end of the trial, and, getting there before anyone else, was able to take

an exclusive picture of the man arriving home.

His red jacket and roaring motor cycle were seen everywhere and he soon became a fixture in Fleet Street. He even turned up on his bike, and in that famous red jacket, at the opening of the National Theatre by the Queen. I remember waiting in my dinner jacket while he peeled off his wet weather gear and smartened himself up before the two of us followed Sir Peter Hall and his party down to the foyer to greet the Queen. As the limousine drew up I noticed that he had managed to get his motor bike parked near the entrance and once again he got back to Fleet Street before me once the evening was over.

At the *Star* David was tending more and more towards sport, which was fast becoming his first love. The head office

Down Wembley way: Keith Houchen captured in mid-air as he scores for Coventry City in the 1987 FA Cup Final against Tottenham Hotspur.
DAVID ASHDOWN

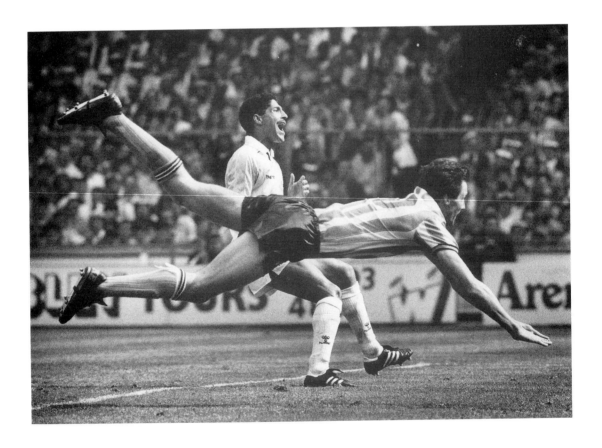

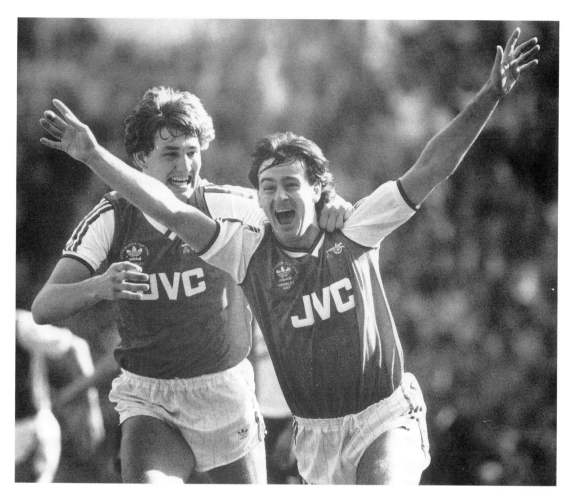

of the *Star* was in Manchester and their sports photographer, John Dawes, worked from there. David steadily built up the sports cover from the London office until, tiring of the tabloid trivia and photographing yet another bingo prizewinner, he persuaded the *Star* to let him cover sport full-time. He worked as the sports photographer for three years, following the fortunes of England teams from Holland to Romania. The main sport covered by the *Star* was football and, although David tried to persuade them that there were other things in life, he had little luck in his attempts to wean them off it.

Down Wembley way: Charlie Nicholas celebrates his goal for Arsenal against Liverpool in the 1987 Littlewoods Cup Final.
DAVID ASHDOWN

At the launch of *The Independent* he saw a great opportunity to spread the range of sport he could cover and, looking at the vast open spaces of broadsheet pages, he decided that he would like to go up-market. He joined at the start and now works directly off the Sports Desk, under the supervision of Charlie Burgess, the Sports Editor. He liaises closely with Charlie, or his deputy Simon Kelner, at the start of each week, and between them they decide which events will produce the most interesting pictures for the paper. They don't go for the major sports all the time, always looking for something that's a bit different. Sometimes on a Saturday they will ignore soccer altogether, and David will be found at a swimming-pool photographing water polo. This is a refreshing approach to sports photography. For years photographers have trailed off to the same old round of matches, sitting in virtually the same spot each time, and producing the same pictures (with different players in the same positions). If there is no major sports event on a particular day, then David will go off to a relatively unimportant fixture and try to get a strikingly different image – for him, the images are the important thing, not the crowd attendance figures.

He comes back from an event and, after processing in the darkroom, will view his negatives on a lightbox using a 50mm lens as a magnifying glass (an old Keystone habit), to pick the best frame. He will then deliver the chosen print to the Sports Desk, who will try to build the page around the picture.

Getting the Picture

Much of the sport that David covers takes place at night under floodlights and this means that he is often pushing both equipment and film stock to extremes. It means that he has to use special developing techniques to pull every ounce of speed out of the emulsion.

A typical evening football match at Wembley starts at home in Lingfield at around 4.00 p.m. when he leaves for the trip around the M25 to the game. He will call in from the car at some point to speak to the Sports Desk to get some idea what

shape of picture will be needed for the first edition. At *The Independent* no one likes to make up the pages before seeing the pictures, but in this case it's impossible as the first edition will have to be completed minus the pictures before the game has ended. So, on this rare occasion, David will shoot to fit the space. He will also confirm with the office exactly where he will meet the motor cycle messenger who will rush the film back in time. An old hand himself, he will know the best spots to meet, and the best way out of the complex for the rider to save an extra minute or two.

He will arrive at the stadium and park his car where it won't become too blocked in at the end of the game, and meet up with the rest of the team of Fleet Street photographers who haunt the touch-lines. They will generally enjoy a meal together, all of them watching their intake of drink (both alcoholic and soft) very carefully; they all know the results of too much to drink from years of bitter experience. This is particularly so on a cold night and generally David will not drink anything for at least an hour before a winter game.

He will have brought his gear to the ground in a metal case, which is useful, both for protecting the cameras and doubling as a seat. He then checks his cameras and the rest of the equipment before going out to face the elements. He wears walking boots with two pairs of socks and a couple of sweaters under a Barbour jacket. If it's wet, and it invariably is in England, he will wear overtrousers to stop that damp feeling in the seat of the pants. He will also have a supply of envelopes ready to put the film in to give to the early messenger.

David has a good system for captions for the film he is sending back. He will divide the back of the envelope into two and label each side of the line for each team. As he takes a picture he will note the numbers of the players in the frame, and put down the numbers in each side of the column so that, for example, for frame one he will know that it shows England's number three and Spain's number six. He will send back the programme with any team changes marked in it to the office and it will be easy to work out who is in each frame for the caption.

At Wembley he will have to sit in a special position which is

allocated to him, but at other grounds where the access is easier he will try and vary the position he shoots from, sometimes sitting at the side between the goal and midfield line. At some grounds even this is restricted by the advertising hoardings – he is not allowed to obstruct them from the television cameras. There will also be the inevitable rows with officials over where exactly he can sit to take his pictures.

Working under floodlights photographers really are pushing the film and the camera to their limits. At Wembley the level of light from the floodlights is quite good, being balanced for daylight colour (a spin-off from the needs of television). Grounds have vastly differing standards and the photographer knows by experience which are the easiest to work under. Crystal Palace and Ipswich have the best, while in some grounds the light is thrown into patchy pools and a player can move a yard to one side and disappear into total darkness just as you press the shutter release.

David uses Nikon F3P bodies which are specially waterproofed – as we saw earlier, the greatest enemy of the photographer out in the open is damp on an electronic camera body, and these special bodies overcome this problem. You cannot afford to miss a winning shot because the camera wouldn't fire at the split second when you needed it. David's favourite lens for football is the 300mm f2.8 Nikkor, which, with its wide aperture, allows for the use of a reasonable shutter speed (usually 1/250 sec.) needed to stop the action. However, with the lens wide open, the depth of field in non-existent and the focusing must be extremely accurate, a difficult task with a fast-moving subject. By uprating the film to 1600ASA and processing in HC110 diluted 10:1 David succeeds in coaxing the very last drop of speed from the emulsion. The results, incidentally, show an acceptable level of grain, even on the 15×12 prints.

As well as the rain, the wind makes life difficult for him by making his eyes water and focusing awkward. Again with the limited depth of field this is just one more problem added as he sits for anything up to an hour totally concentrating on the action on (and sometimes off) the field without a break. He is not seeking simply to photograph the goals, but has to work

hard to seize any opportunity for a well-composed picture, and he cannot afford to let his concentration wander for a minute. He watches most of the action through the viewfinder, constantly framing and making adjustments to that ever-critical focus of the lens.

At a night game David will have just ten minutes before the messenger has to leave for the dash back to City Road or, if the match is a long way out of town or abroad, to leave the field to process and wire. The mechanics and theory of wiring have been discussed earlier – each time he has to work away from home the conditions are generally less than perfect.

He will start the evening by checking that a phone line has been installed ready for use – this will have been ordered in advance by the office. After checking out the phone lines and

Wiring photos from the Israel v. England soccer match in Tel Aviv in February 1988. From left to right: Monty Fresco (*Daily Mirror*), David Ashdown (*The Independent*), Peter Jay (the *Sun*). Three Nikon transmitters are in use (£45,000 worth). Note the neat wiring!

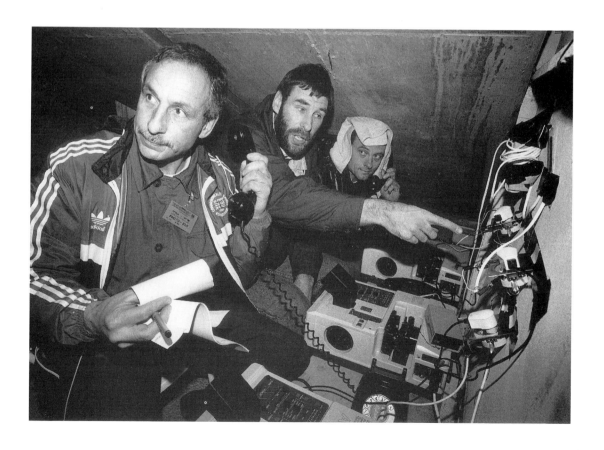

Opposite Safety first. Ian Botham
takes evasive action.
DAVID ASHDOWN

Overleaf left Joe Bugner.
DAVID ASHDOWN

Overleaf right Frank Bruno.
DAVID ASHDOWN

maybe sending a test wire picture if he has time, he will find somewhere to process the film. He travels with a portable darkroom kit, complete with ready-mixed chemicals, spirals and tanks which he loads in a changing bag. He needs to find a sink and running water and, if possible, a fairly dark room with no windows. The Gents is usually tailor-made for these requirements and David has processed film in lavatories the length and breadth of the land. The most practical tip he can give on this subject is to develop a good strong whistle – in many public loos the lock usually won't work, and you need your privacy during these sessions with the changing bag!

To put David's job into perspective, on a mid-week match away from London which kicks off at 7.30 p.m. he needs to have a usable picture on the sports desk by 8.45 p.m.. This allows just ten minutes on the field, ten more in the 'darkroom' and then a quick run up the stairs to the telephone point to get the stuff moving. There isn't much room for error, but he manages to come up with the goods time after time.

At *The Independent* David does try to keep away from football as much as he can, preferring to look at something different to produce a more original picture, and he can sometimes be found at a canoe slalom on a Saturday afternoon rather than at a mass spectator sport. His favourite sport is cricket (my suspicion is that he just likes to catch up on the sunshine after a long winter of football) – he really enjoys the game and feels that it produces some of the most spectacular sports images, not always of wickets falling, but, again, of those little incidents which sometimes escape the general gaze. The equipment is simpler – a 600mm lens with a 1.4 times converter turning it into the equivalent of a 840mm lens, mounted on a motor-driven body on a tripod. Cricket seems to me to be such a gentlemanly game, they even call it off when the light drops and the lenses have to be opened up! Again, however, it is a matter of supreme concentration; David has to watch every run-up through the viewfinder in the hope of a picture and can spend several overs without actually firing the shutter. He also has to be aware of incidents off the wicket, and he keeps a second camera with a long lens close at hand for any developments.

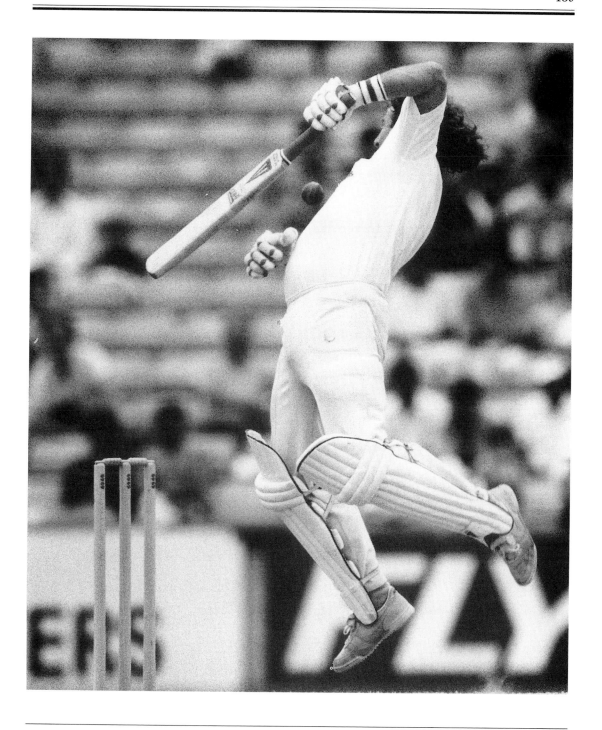

It is also possible sometimes to set up cameras with lenses pre-focused on the game around the ground, and to release them with infra-red or radio releases in an attempt to catch the same incident from several angles.

Much use is made by sports photographers of motor drives and, at first thought, you may feel that they make the task easier. In fact, this is not always the case. David tends to use his motor drives mainly just to advance the film and doesn't often let them run as a sequence. He was once covering the end of the Derby from a position directly across the course from the finish. As the horses crossed the line he let the motor run and when the film was developed he ended up with a sequence of the horses before and after crossing the line, but not one frame showed them actually *on* the line. 'Using a sequence camera you never really know what you've got until

Frank Bruno comes to grief at Wembley in 1986.
KEITH DOBNEY

you process the film and look at the negs,' he says. 'I prefer to try and pick the right moment first time, use the motor to wind on more quickly than I can do myself, and then try for a second bite if there's time.'

The most tiring sports to cover are boxing (where you have the physical strain of bending almost backwards to look straight up into the ring as the floor sticks into your chest), badminton, and squash, where the sheer speed of the action means you cannot let up for a second. With the weight of all the film and equipment he has to cart around to the various venues he also needs a degree of physical fitness.

Some of his greatest successes have come from America where he covered the European challenge for the Ryder Cup at the lovely golf course in Muirfield, Ohio. He had set up his equipment in the press centre and, because he was five hours behind London in time, had to make a very early start each day. He would take a few pictures, race back to the inevitable lavatory and emerge blinking into the sunshine with his film. We would call him from London and minutes later his pictures would be with our Sports Editor.

On the final day David felt that Europe had a fair chance of taking the title and knew that this was a sufficiently important event to make the front page. He shot a picture of Tony Jacklin looking pleased with himself at first light and wired that over. It was indeed destined for the front page that night as the story developed and it became clear that David's instinct was right. The original picture was schemed in and at 3.00 p.m. in Ohio Tony Jacklin exploded with joy when the team took the cup. It was now 8.00 p.m. in London and David put a fast call into Michael Sullivan, who was manning the night Picture Desk at *The Independent*, saying that he had got a great shot that would just drop into the same space as the set-up shot of a few hours previously. He rushed in and out of the lavatory, dried his film with the hair drier he always carries for the task, and by 8.40 p.m. had got the picture across. Sullivan was able to offer the picture immediately to the Editor who readily agreed to change the original one for a better one, and next morning 400,000 copies of the picture graced British breakfast tables. As David Ashdown was the only British daily-paper photographer at the golf, *The*

Independent had been able to show off a fine exclusive and it had been provided by the intelligent and thoughtful planning that David had made that afternoon. Commentators often talk of 'pressure shots' in golf, but I would suggest that David was under just as much pressure as any of them for his shots.

He now counts himself, as most other photographers do, as being extremely lucky to be paid to watch something that other people pay money to go and see. However, the pressures are great, and he knows that he sometimes only has a few minutes to produce a picture, even when the action has barely warmed up.

He loves sport and that love and understanding of the players shows through time after time in his pictures.

Does he play sport himself?

'I play golf very badly when I have the time,' he says. 'I see too much good sport played at very close quarters by great exponents of the game to think that I have even a remote chance of catching up with any of them in my lifetime.'

The State of the Street

It's a long and winding road to Fleet Street as we have seen. It's a hard journey for some, and others don't even set out on it. Some get left by the wayside and some go straight along it at a hundred miles an hour. There are many turns and some dead ends off the road and how far along it you want to go is entirely up to you.

In photographic terms, you may get far more satisfaction out of pursuing your own ideas rather than fitting in with the ideas of others. The sum total of your work for the day on one of the tabloids may well be a slightly out of focus smudge of a person crossing the street – as we have seen earlier, it's the person and not the picture who is important there. For others there will be the satisfaction of seeing the efforts of days of patience rewarded by a sympathetic layout and display of their images. And there is much in between.

I have followed the route of this book, maybe not exactly as written here, but I went from the darkroom of the *South Wales Echo* in Cardiff at the age of eighteen to Picture Editor of *The Independent* at thirty-eight. In between I worked on a new newspaper at Hemel Hempstead, went back to Cardiff as a photographer on an evening paper, and was transferred to Carmarthen to work as a district photographer for the *Western Mail*, the national newspaper of Wales. From there I became the Heathrow Airport photographer for the Press Association, Britain's national news agency. I worked in Fleet Street, again for the PA, as a photographer and travelled extensively, both in Britain and as far afield as Canada and India in the search for news pictures. I decided to become an editor and joined the London Desk of the Associated Press, where I intended to stay for a year to gain experience. In the event after just six months I was offered a job on the *Evening Standard* as an editor and helped with their page three 'News on Camera'. I became Deputy Picture Editor of the *Standard* after it merged with the *Evening News*, and then joined the

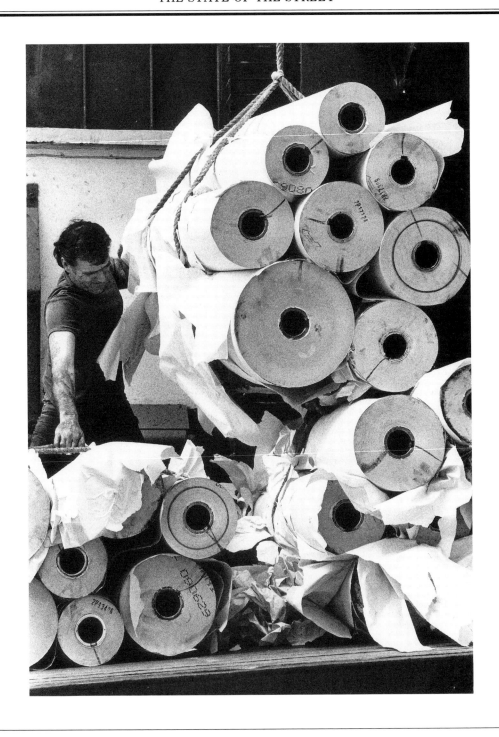

brand new *Mail on Sunday* as Deputy Picture Editor. I stayed there for nearly five years and was then offered the chance to picture edit *The Independent* in September 1986. So it has been quite a long road for me. Yes I've been lucky, but I've worked hard at capitalising on that luck.

I've worked in Fleet Street for fifteen years, in an agency, and on evening, Sunday and daily papers, and I have worked there during the period of its greatest change, not to say revolution.

The revolution was marked by two events – the first was Eddie Shah's plan to launch *Today* newspaper, a magnificent idea flawed by lack of planning at the start; and the second was the move of the Murdoch papers to Wapping. Of the two, perhaps the most significant was the move to Wapping. I was at the *Mail on Sunday* on the Saturday night when the *Sunday Times* supplement was first printed there, and at the moment

Opposite A view of the past: reels being loaded in the old *Sun* building in Bouverie Street.
ALUN JOHN

Above Reel ends outside the *Sun* in Bouverie Street.
ALUN JOHN

we heard that the lorries had left the plant, Stewart Steven, the Editor of the *Mail on Sunday* turned from his red-backed chair on the 'back bench' and said to anyone who would listen, 'From this moment Fleet Street will never be the same again. It has ceased to exist as we know it'. And he was absolutely right.

In the fifteen years that I've been there it has ceased to exist quite literally. Now no one has offices in Fleet Street, except for the Press Association and Reuters news agencies who share the Lutyens-designed building at number 85. Newspapers have scattered to the corners of London. Our office at *The Independent* is in City Road, on the edge of the City square mile. *Today* is at Vauxhall Bridge Road, and the rest of the Murdoch stable are at Wapping. The *Mail* group is in Kensington and the *Observer* at Battersea Bridge. Little contact takes place between people from different offices and the business is the poorer for it. It is no longer possible to slip out for a drink in the certain knowledge of meeting your friends and exchanging the latest gossip. Fleet Street used to be a magnificent rumour factory, with people being hired, fired, rehired and promoted over a couple of glasses of wine in El Vino's. The place was like a village, a concept which is possibly a little difficult for those outside to understand, with the traditional image of a rat race of cut-throat competition. There *was* competition, which, to my mind, was no bad thing. I viewed the situation as a set of professional people operating in close proximity to each other, spurring each other on to better things. This was certainly true in the photographic side of the business – you knew that if you didn't get in, someone else would.

You have only to look at the papers in some of our large towns and cities where there is no direct competition to see the results of a monopoly where there is no one to push them to better efforts. The results tend to be dull pictures of the same dreary people and events, presented in a lack-lustre style. They have become fixtures in the towns they serve, feeling that they don't need to change or improve and in most cases they don't know or (worse) seem to care that their photography is the weak point of their paper. There *are* bright spots, and there are many photographers in the provinces

Opposite The *Daily Telegraph* building in Fleet Street. The building remains the same but the newspaper has moved on.
ALUN JOHN

trying hard day after day to push up the standards of photography, but it is a war of attrition and there is a limit to the number of times someone can launch themselves yet again against the brick wall of indifference presented by some editors. Eventually, the photographers give up and move on to better things – it's more desirable surely that better things should move on to some of the papers.

The whole process of newspaper photography is changing for many reasons. Improvements in picture reproduction enable photographers to tackle things in a way that is different from the old 'flash-bang-wallop' days. When photographic reproduction was poor, pictures had to be taken in such a way that the detail was bold and not cluttered, and the lighting was harsh and 'contrasty' in order to show up the subjects. With the improvements, pictures that are well lit, well composed and thought-out can now be seen properly.

For many years it was thought that some papers used dull pictures, and with the apalling reproduction, no one could argue. Now that the reproduction has dramatically improved, and you can see the pictures sharply and clearly, it is possible to say positively that they are, on the whole, extremely dull. The flash-bang-wallopers are still around in Fleet Street, but they are like dinosaurs. One day they will have no pastures to graze in as new technology embraces every paper, and a new breed of photographer will take over. The new people will be thoughtful and well versed technically, they will not be overawed and too much in love with the technology to let it influence them. One of the greatest failings of *Today* when it started was that it was a technology-led newspaper, which thought that all the equipment would compensate for the lack of quality of the journalism. It didn't, and the whole project had to be both rethought and relaunched.

We have also seen *Now!* magazine come and go. Again, this was a good concept – a colour news magazine with up-to-the-minute stories. Perhaps the British appetite for this sort of magazine is meagre – the results towards the end were good, but people wouldn't buy the idea.

The *London Daily News*, too, has come and gone. Here, the quality of the journalism was excellent, but the concept was wrong. Robert Maxwell chose to launch a 24-hour paper with

morning and evening editions; if he had concentrated on the evening edition, and attacked the *London Evening Standard* head-on, I think the *Daily News* would have had a much greater chance of success. The *Standard* was for a long time in a monopoly position following the closure of the *Evening News*, and it was going in the same direction as most papers that don't have any competition. If its marketing had been right the *London Daily News* would have given the *Standard* a real run for its money.

The tabloids remain obsessed with trivia, both in terms of news reporting and photography. They are transfixed with Royalty and will spend thousands of pounds sending photographers around the world following our Royal Family. They will produce wonderful pictures of the Princess of Wales's new stockings or ear-rings, and project this at their

'Madame' Cynthia Payne leaves a South London court after being acquitted. She is 'under the protection' (as they say) of a national Sunday newspaper. KEITH DOBNEY

Opposite The train now leaving Waterloo is for Ladies' Day at Ascot. This picture gives an amusing slant on an annual event.
BRIAN HARRIS

Below Brian Harris at work in part of a newly-discovered cave complex in Yorkshire. The camera, with the shutter open, was mounted on a tripod and flashes let off around the cave to provide illumination. Brian can be seen on the left holding one of them.
BRIAN HARRIS

readers from their front pages. They also follow every move of the soap opera stars and cover photocall after photocall for the most unimportant of product launches. *The Independent* on occasions uses what in the final analysis could be called 'trivial pictures', but they do at least show visually interesting trivia.

The Independent has given photographers freedom, both on the paper and for our rivals. Other photographers now point to what is being done at *The Independent* and question why their own papers cannot do the same. They have a hard task sometimes. I watched two of our photographers collecting Nikon awards at a West End hotel one Thursday evening – Brian Harris for his superb feature set, and David Ashdown for a sports portfolio. After the presentation I was told by a consultant picture editor for a colour magazine that he thought I personally had done more damage to photography than any single individual in the last forty years. The next day I

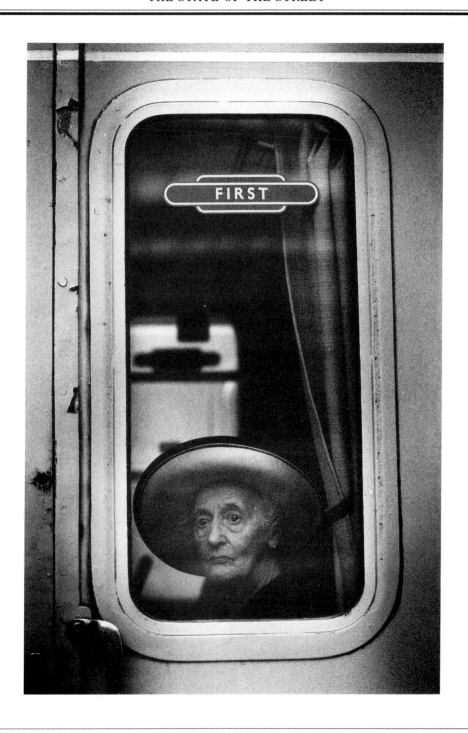

collected my award from Granada TV for what they felt was the best use of pictures by anyone since the days of *Picture Post*. I still don't know which was right.

Technology has swept through Fleet Street, in some cases bringing dramatic improvements. But no camera, however technologically smart, ever took a picture by itself, just as no word processor ever wrote a great novel. The basic ingredient of newspapers must be good journalism, written and visual. The technology that helps talent in any way should be readily embraced, but that embrace should not smother basic ability. The technology should be used as the tools of the job and nothing more. *Today* hit the streets as an all-singing, all-dancing technological miracle, and while the means may have been revolutionary the ends were sadly lacking in excitement.

A good camera does not make a good photographer; a good idea does, and a great idea executed with indifferent equipment will always win out over the reverse.

The agencies have an almost impossible task. With no style of their own to work for, not producing their own papers, they have to try and strike a middle ground that will please all their clients. This results in a 'safe' picture time after time. Not all their clients need the same approach and they would soon be out of business if they couldn't please most of them. The international agencies are also locked into a race to produce the first picture from a news event at all costs, just to beat the opposition. They are also involved in a sort of arms race with their technology. If one gets a new digital picture-transmitting service, then the others must follow or fall by the wayside. In many cases all they have succeeded in doing is beaming uninspiring pictures around the world faster than their rivals. To my mind this is not a great and notable achievement.

The domestic agency, PA, is the prisoner of its clients. Again, with no one single customer, its photographers will always go for that safe picture rather than risk the flood of complaints from their provincial clients.

The tabloids continue to put vast sums of money into stories and pictures and to throw the finest results into the bin. As we have seen earlier, photographic ability or appreciation is not often in the list of qualifications for those who actually choose

and present tabloid photographs to the readers. People will be sent literally to the four corners of the world on stories of substance and produce good, interesting and well-composed pictures. They will have to battle their way into the papers through the mounds of soap opera and Royal pictures that clog up the tabloid arteries.

When the Press Photographers' Association held its first exhibition at the Barbican the walls were lined with pictures of the highest standard and quality – sadly, most of those from tabloid photographers had not even seen the light of day. Only one newspaper editor attended the opening – I won't give him away other than to say that I see him every day at the office. Until editors take photography seriously, and take notice of what photographers have been doing for years, and what picture editors have been saying for years, then the tabloids will continue to underplay and under-use the not inconsiderable photographic talents that are working for them.

Will colour be the way ahead? I honestly don't know. I personally think that colour should only be used when it actually adds something to the information that the picture is giving the reader. When *Today* started, their daily commitment to the use of colour led to stock heads of footballers being used day after day – not exactly pushing at the frontiers of modern journalism. Colour can add a great deal to a picture, but we must not allow ourselves to be seduced by it, thereby running the risk of losing sight of the basic content of the picture. If it's a bad picture, it simply becomes a bad picture in colour.

The finest use of colour that I remember was in the Scottish *Daily Record* (the Glasgow-based sister paper of the *Daily Mirror*) of the dreadful fire at the Bradford football stadium. The orange flames consuming the stand against the green of the pitch really added a further dimension to the story. I am not sure that the colour centre spreads in *Today* offering advice to women on how to make their way up a career ladder actually add anything. When he was Editor of *Today* Brian McArthur asked me why *The Independent* didn't use much colour. I told him (perhaps rather too loftily) that until we could get it better than his it wouldn't be worth bothering. I

still need to be convinced that that's where the way forward for papers lies. Documentary photography seems to me to be natural in black and white and sometimes the colour just seems to get in the way. Assignments will be chosen sometimes just because they will look good in colour, and not because they are actually worth covering. Readers feel happier with their news pictures in black and white – monochrome seems to add authority to the image.

Pictures are becoming more important ingredients of newspapers, and perhaps *The Independent* can claim a little of the credit for that. It may be easy to pick holes in *The Independent*, but more people have taken more notice of the pictures in the paper than in any other. One of my ambitions when I went there was to get readers talking about the pictures in the same way they talked about the articles – taking notice of them, sometimes criticising, often praising, but constantly acknowledging them – and in that respect I suppose I have succeeded in some measure. We seem to have influenced other papers. Very often in my visits to the provinces I have heard people say that they like to try and use the pictures in their own papers '*Independent* style' from time to time. I take this as one of my greatest compliments. For us '*Independent* style' doesn't come along once in a while, it's a constant, and something all of us, from the Editor of the paper down, work hard at.

Documentary in monochrome. Voting at the National School at Oat Quarter, Inishmore in the Aran Islands.
JEREMY NICHOLL

Left Documentary in monochrome. Opening up the Crisis at Christmas hostel in South London a couple of days before Christmas 1987.
BRIAN HARRIS

Below A picture is worth a thousand words. The SDP conference at Portsmouth, 1987. Left to right: Dr David Owen, Charles Kennedy, Robert Maclennan and Shirley Williams. This picture says more about the SDP-Liberal merger struggle than pages of analysis.
BRIAN HARRIS

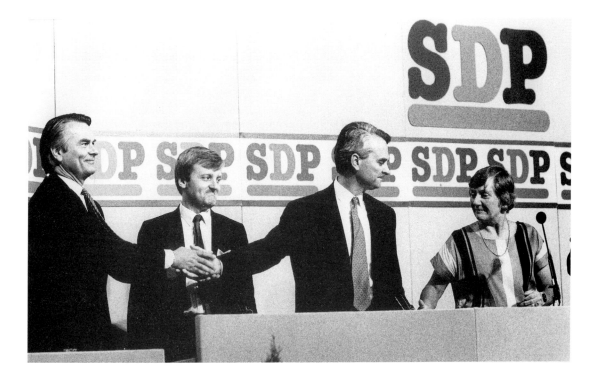

This book has taken us from Bracknell to Beirut via Birmingham and the streets of Belfast. It is a taste of what life in photography can be like, but it can by definition only be a small taste. It shows how far a photographer can go in the search for pictures, from plugging away at the seemingly endless round of summer fêtes, looking for something different, literally to the other side of the world, for the same purpose.

Photography is like music. There are many styles, many players, many composers, but they all have one thing in common – they are creating music. It is just the same in photography. There are many branches of the profession, from people working in studios, to those working in the back streets of a Middle East town trying to make sense out of a conflict, but they are all united by a love of pictures.

The greatest cliché of all is that a picture is worth a thousand words, but how accurate that is. Many thousands of words may be written about a subject and much learned debate can take place over an emotive issue, but one picture that is properly thought-out can say in a fraction of a second many of the things that cannot be put into words.

The road to Fleet Street is long, and on the way you can make a lot of friends and a lot of money, and you can see your name in print. You should never lose sight of the end result that you are aiming for, the ultimate purpose of photography, which is to convey to someone who cannot be with you the essence of a moment preserved.

Photographers are daily in search of images that will shock, amaze and amuse you on your breakfast table. I hope that I have gone some way to explaining the motives that drive people to push themselves as far as they can, sometimes physically, often emotionally, to share that moment with you. Photographers are strange people – they will do anything, literally anything, to get that picture that will beat their rivals on to the page. I hope this may make you appreciate their efforts a little more.

Index